# PENARTH
## THROUGH TIME
David Ings

AMBERLEY PUBLISHING

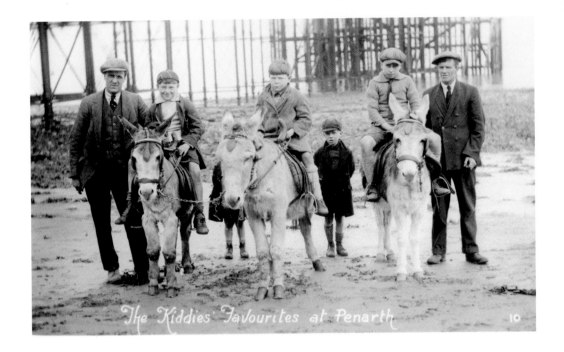

The Kiddies' Favourites at Penarth

*To Hannah*

First published 2009

Amberley Publishing Plc
Cirencester Road, Chalford,
Stroud, Gloucestershire, GL6 8PE

www.amberley-books.com

Copyright © David Ings, 2009

The right of David Ings to be identified as the
Author of this work has been asserted in accordance
with the Copyrights, Designs and Patents Act 1988.

ISBN 978 1 84868 746 2

British Library Cataloguing in Publication Data.
A catalogue record for this book is available from
the British Library.

Typeset in 9.5pt on 12pt Celeste.
Typesetting by Amberley Publishing.
Printed in the UK.

# Introduction

In 1851 Penarth was little more than a small rural farming and fishing village, being one of the parishes contained within the Hundred of Dinas Powys. In 1875 three of the parishes — Penarth, Cogan, and Llandough — were merged together into the Penarth Local Board, giving a population of 6,228 persons by 1881. This figure had doubled by 1891 with the opening of the railway. By 1951 the population had risen to 18,528, climbing to 24,119 in 1981 and decreasing to 20,430 in 1991. The town's population was recorded as being 23,245 in the 2001 Census, although further growth has taken place since then. So the population of Penarth could fit into the new Cardiff City Stadium!

Penarth owes its development to the massive expansion of the South Wales coalfield in the nineteenth century. Penarth Dock was opened in 1865. At the Welsh coal trade's zenith in 1913, ships carried over four million tons of coal in a single year out of Penarth docks.

The coal trade from Penarth docks eventually petered out during the 1950s, and up until 1965 the basins were used by the Royal Navy to mothball dozens of Destroyers and Frigates. By 1967 the docks lay unused and derelict and much of it was used for landfill. In 1987 the new Penarth Marina village, with some 350 yacht berths and surrounded by extensive modern waterside homes and several marine engineering yards, opened on the disused docks site. The original dock office and Excise House is now in use as restaurants, with only the Grade II listed Marine Hotel remaining derelict and boarded up awaiting suitable redevelopment plans.

With the arrival of the railway connection to the Welsh valleys in 1878 came the regular influx of day-trippers, often hundreds of them at weekends and bank holidays. Earl Plymouth's land agent Robert Forrest sought to actively discourage the 'rabble from the hills', who came by train, and 'those persons who swim in the sea either without a bathing costume, or without sufficient modesty to change into one hidden from public view.'

The developing summer holiday trade was supported by a large number of quality hotels. The biggest and grandest of the hotels were the Esplanade Hotel on the seafront, the Marine Hotel at the mouth of the docks, Penarth Hotel, the Royal Hotel, the Washington Hotel, the Glendale and the Lansdowne.

Houses in Penarth vary from imposing three-storey red-brick Victorian houses found on both Plymouth and Westbourne roads to compact stone terraces in Cogan and upper Penarth. Many of the originally large family homes, with servants' quarters on the top floors, have now been adapted for multi occupancy as flats and apartments. Penarth Marina features modern townhouses, apartments and designer penthouses.

What is now the main shopping area of Windsor Road was originally residential housing. The owners sacrificed their front gardens to build shop extensions, although the original house architecture can still be seen above the current shops.

Imposing detached villa residences along the cliff tops and in Marine Parade or 'Millionaire's Row' that looked across the Channel to the Somerset coast and the islands of Flat Holm and Steep Holm were built by wealthy shipping and dock owners. Several larger properties are nowadays split as apartments or adapted as residential care homes.

Penarth earned its wide reputation as 'The Garden by the Sea' because of its beautiful parks and open spaces.

The TV series *Tracy Beaker* was filmed at Holm House in Marine Parade. *Gavin & Stacey* used All Saints' church hall for the barn dance, whilst the Glendale Hotel doubles as Luigi's Restaurant in the series. Cosmeston was used as one of the filming locations for the BBC TV drama series *Merlin*, broadcast in Autumn 2008. Penarth has been used in recent years as a filming location for *Doctor Who* and its spin-offs *Torchwood* (an anagram of Doctor Who) and *The Sarah Jane Adventures*. The doctor and Rose's reunion was filmed on 13 March 2008 at the High Street, Arcot Street, Queen's Road, Paget Road intersection, and it was watched by 8.78 million viewers on its broadcast in June 2008. I feel it is appropriate to mention this in a book entitled *Penarth Through Time*.

David Ings, September 2009

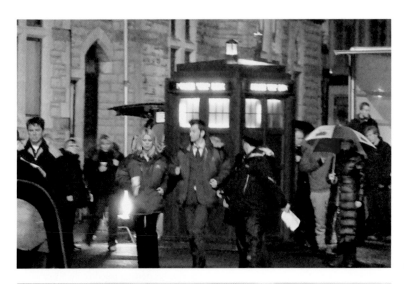

13 March 2008, Filming *Dr Who* in Penarth, John Barrowman, Billie Piper, David Tennant and Catherine Tate. © Paul Dyer

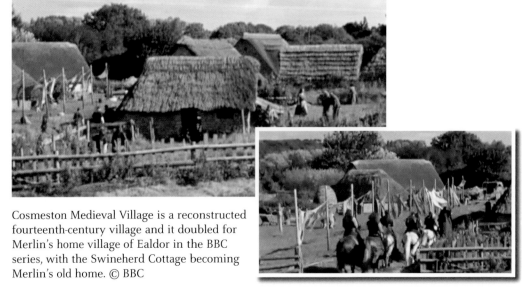

Cosmeston Medieval Village is a reconstructed fourteenth-century village and it doubled for Merlin's home village of Ealdor in the BBC series, with the Swineherd Cottage becoming Merlin's old home. © BBC

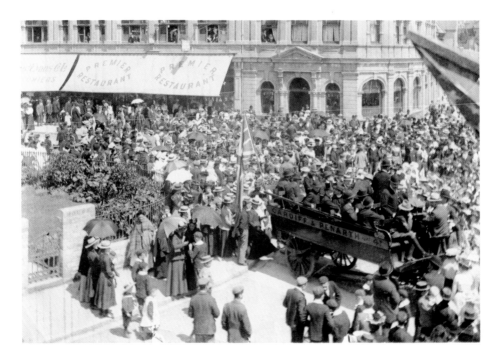

## Town Centre

The scene in the town centre on the occasion of the declaration of peace at the end of the Boer War in 1902. One of Solomon Andrews' horse buses, blocking the entrance to Bradenham Place, proudly flies the Union Flag and advertises 'Cardiff & Penarth fare 4d'. The Premier Restaurant's and David Evans, costumier's awnings provide some welcome shade for the large crowd. Windsor Arcade and the adjoining Lloyds Bank were built in 1898 for Solomon Andrews. People can be seen looking out at the scene below from the vantage point of the Temperance Hotel. The flag on the right is flying from the top of the Grosvenor Restaurant. An estate agent's and optician's are now between Lloyds Bank and Windsor Arcade.

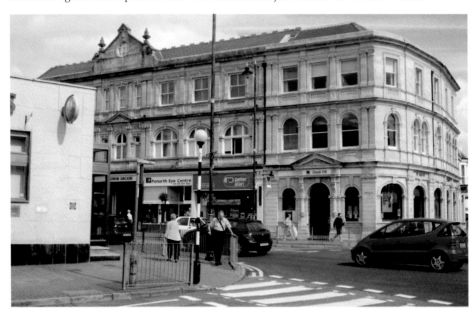

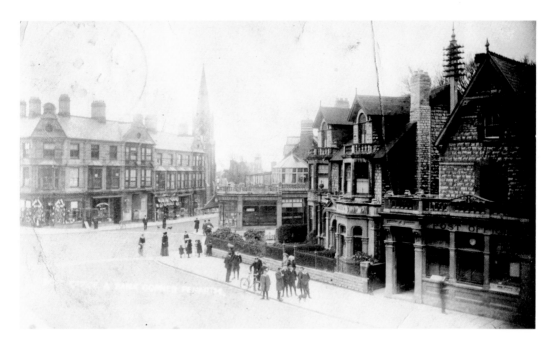

### Old Post Office and Bank Corner

Opposite Windsor Arcade is the London and Provincial Bank. It became Barclays after bank amalgamation in 1919. The post office next door was transferred to the other side of Bradenham Place, and until the late 1950s it housed Penarth's manual telephone exchange. Abbey National now occupies 4 Windsor Road. The Principality is now on the site of Williams Dining Rooms and the Grosvenor Restaurant, whilst a jeweller's, a hairdresser's and an estate agent's occupy the shops at the top end of Stanwell Road.

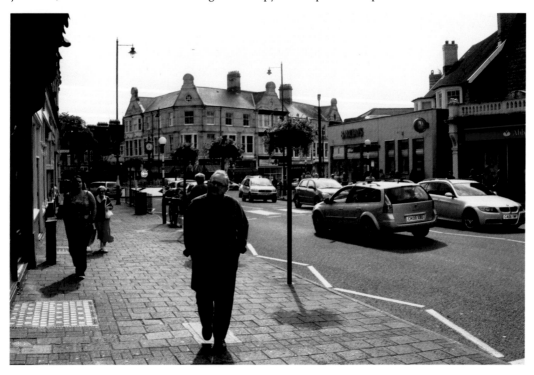

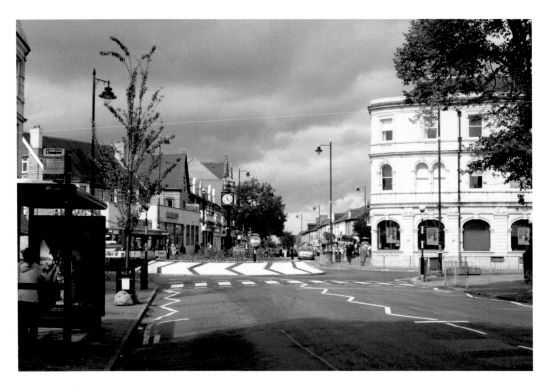

## From Windsor Terrace

Viewing down Windsor Road from Windsor Terrace. Notice an electric lamp alongside the gas lit lamp on the site where the roundabout now stands. A boot and shoe manufacturers are on the corner of Windsor Terrace and Stanwell Road. Nowadays this site is occupied by a jeweller's, with a solicitor's, hair salon, shoe repairer and a tandoori restaurant at the top end of Windsor Terrace.

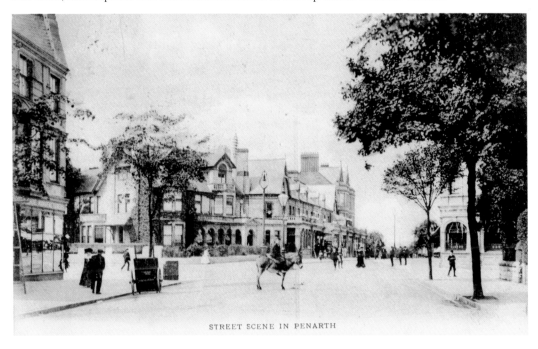

STREET SCENE IN PENARTH

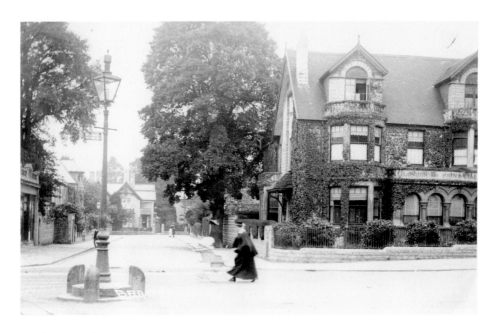

### Bradenham Place

This 1910 postcard — produced by H. Woodward — The Noah's Ark, 6 Windsor Road, shows the junction of Windsor Road and Bradenham Place. The sign hanging from the lamppost points the way to the beach and the public baths. The London and Provincial Bank is shown on the right. A nanny is seen pushing her charge along Windsor Road. Note that only the electrically lit lamp remains and the stone slabs protecting the lamp post from damage by the many carts used for deliveries.

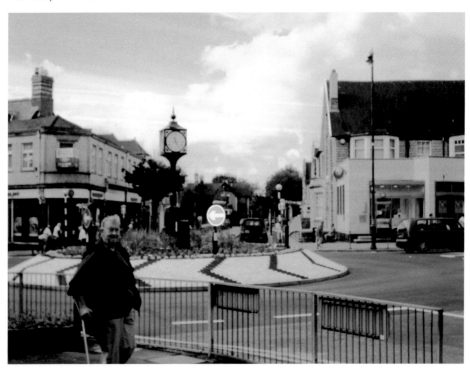

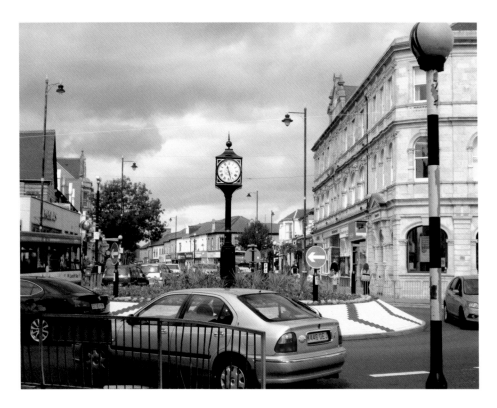

## Windsor Road

Lloyds Bank and the Premier Restaurant are on the right foreground of this 1910 Viner postcard. Windsor Road was originally residential, but towards the turn of the century a 'town centre' was created with shop conversions. The use of the houses' front garden space achieved projecting shop fronts without sacrificing a wide pavement. The original nineteenth-century upper floors remain clearly visible. The roundabout clock was erected in 1987 to commemorate the fiftieth anniversary of the Rotary Club of Penarth.

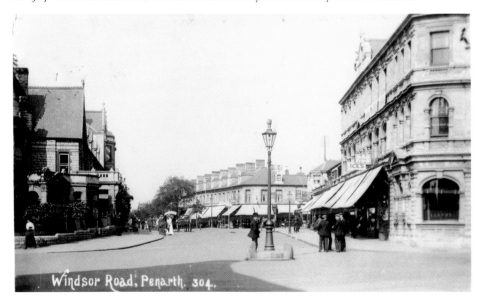

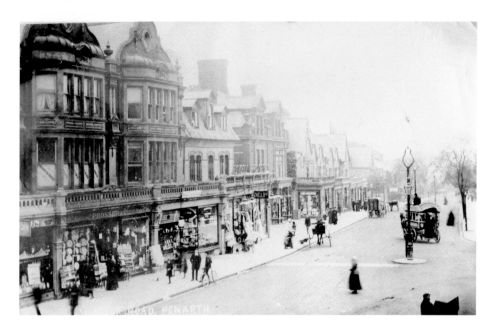

### Windsor Road Shops

This 1906 postcard shows the shops further down Windsor Road, including Prosser & Co., furniture shop; Stranaghan & Stephens Stores; and Howells, draper's, which opened in 1884 and became David Morgan's. Solomon Andrews' horse-drawn buses left Glebe Street next to the St Fagan's Hotel every quarter of an hour for the journey to Cardiff, which took half an hour, at a cost of 4*d*. Spar, Starbucks, a ladies' fashion shop, an off licence, Boots and the Co-op now occupy these shops.

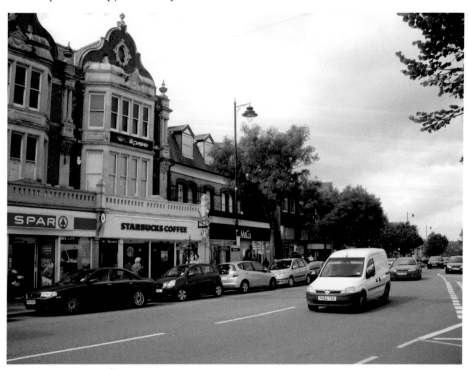

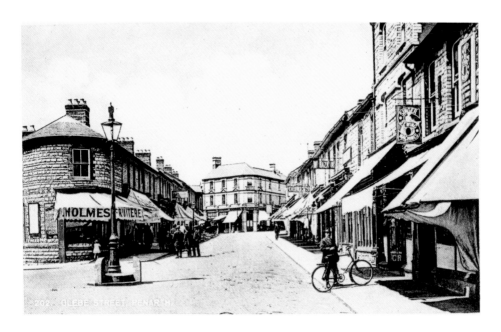

## Glebe Street

This postcard, taken around 1913, shows the town centre end of Glebe Street, with Holmes the fruiterers, Olivers the shoe shop, Longstaffes' 1d bazaar, Pugsley the grocer, and a sign advertising Singer sewing machines hanging outside their shop. Robert James ironmonger's shop was, and still is, on the opposite corner to Holmes (which is now a Chinese takeaway). Further up Glebe Street were Evans' the butcher, Taylor's the barber, Liptons grocery, Mannings the watchmaker, Matthews boot and shoe shop, Walter Davies' Glebe Café and Davies & Co. Drapers.

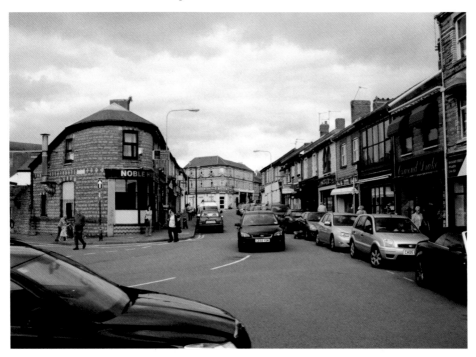

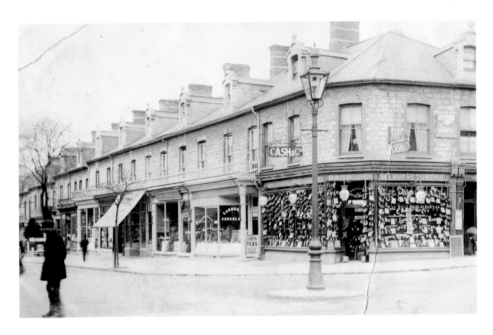

## The Junction of Glebe Street and Windsor Road

This postcard (dated 1912) shows Cash & Co., the boot shop on the corner of Glebe Street and Windsor Road (now occupied by the Tenovus Cancer charity shop). Just around the corner in Glebe Street was Miss Bliss' Haberdashery. Further down Windsor Road was Camplin's Dairy, Thomas' coal merchants, Cuthbert's Confectionery shop, Brockington's the tailors, Styles the photographer and Thomas Rodgers' Windsor Stores on the Arcot Street corner (now Wasons DIY shop).

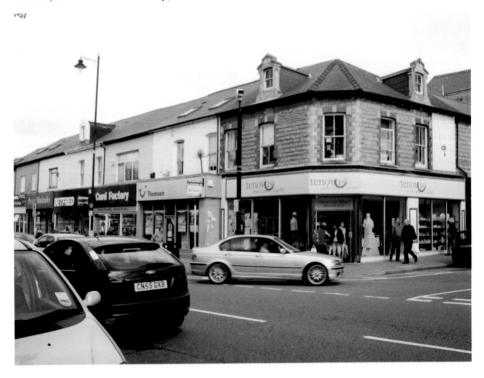

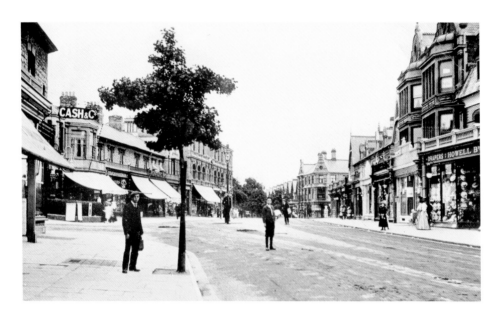

## South Side of Windsor Road

Looking back up the south side of Windsor Road in this 1910 Ernest T. Bush card we see Howells Bros draper's shop and Prossers the furniture store. A policeman is standing at the lamppost with the shops of Penfound Brothers, W. K. Lewis and 'Owen the Don' the barber behind him. Today the Nationwide, the Marie Curie Cancer Care shop, a café bar and Holders menswear are there. Thomson Travel and the Card Warehouse are shown left foreground.

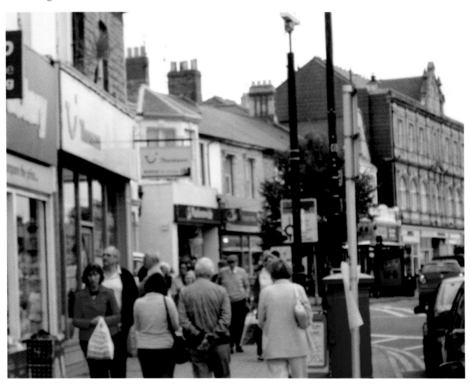

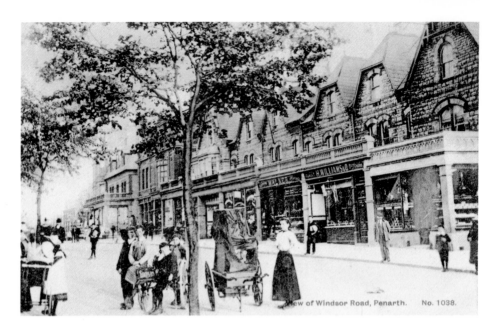

View of Windsor Road, Penarth.    No. 1038.

## View of Windsor Road

This card, dated 1906, shows a butcher's boy and other delivery boys posing alongside a knife-sharpening machine. H. Williams & Co. the butcher's, Robert Drane the chemist (became Gerholds in 1911), Walker's Bakery, Josh Rees' Drapery, and Fulton Dunlop & Co. the wine and spirit merchants are seen. A pharmacy still occupies the corner shop, with a tanning salon and Greggs bakery next to it. Woolworth's closed in January 2009.

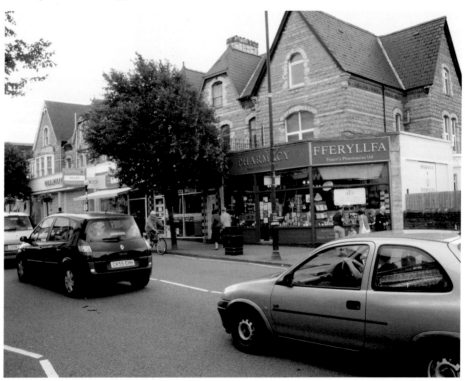

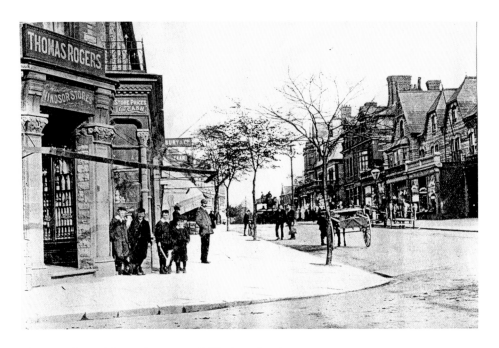

### The Junction of Arcot Street and Windsor Road

This shot is taken from the corner of Arcot Street and Windsor Road. The street was named after the Battle of Arcot in India in 1750, which Robert Clive (Clive of India) won. The street was used as a route for the horse-buses operated by the Taff Vale Railway to convey passengers between the railway station and their hotel, the Penarth Hotel. Thomas Rodgers' Windsor Stores is on the corner (now Wasons DIY, with a discount store and the Bear's Head pub next door).

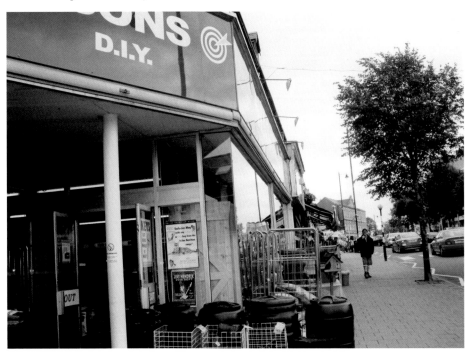

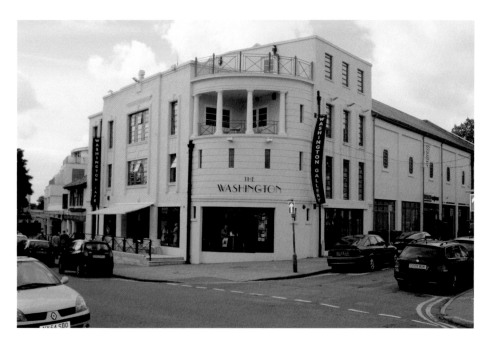

## Library Foundation Stone and Washington Gallery

This photograph shows the laying of the foundation stone of the new library building by Samuel Thomas on 10 September 1904. The new library opened in 1905. The Washington Cinema was built opposite the library, with a classical Art Deco frontage, on the site of the Washington Hotel (so named in the hope of attracting American visitors), and it opened in 1938. The Washington closed as a cinema in 1970, and after several years as a busy bingo hall and then a night club, it is now converted as a coffee house and art gallery. The Oriel Washington Gallery is managed by the not-for-profit registered charity Penarth Arts and Crafts Ltd.

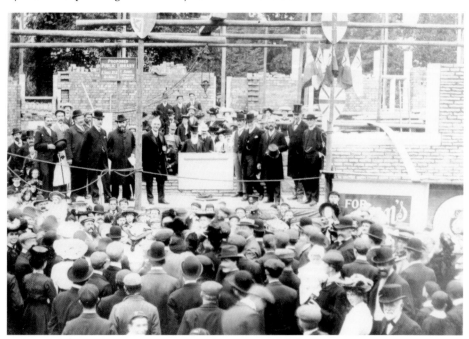

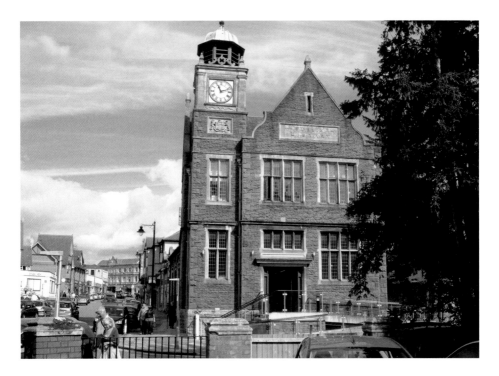

## The Library and Christchurch

The library doorway originally faced into Stanwell Road, but nowadays the entrance is in Rectory Road. Christchurch was built in 1897 on land in Stanwell Road, offered to the Congregationalists by Solomon Andrews in exchange for the site of their iron church on the corner of Windsor Road and Railway Terrace. Joseph Parry was a member of Christchurch (but is buried in St Augustine's) and played the organ there. The 110-foot spire added grace to the 'roofscape' of the town until the church was demolished in 1989. The Cancer Research UK shop, a gift shop, the George Thomas Hospice shop and offices are now here.

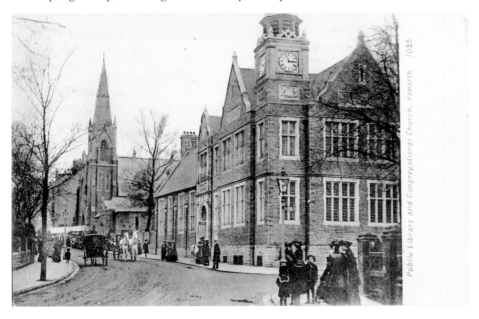

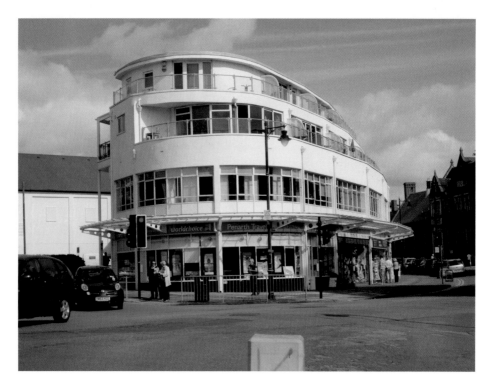

**Stanwell Road**

Scaffolding can be seen around the 'New Library', built in 1904. The 2009 view shows Washington Lofts, the luxury loft conversions with a contemporary Art Deco design. The ground floor contains Penarth Travel, a lifestyle clothing shop, an estate agent's, A. B. Snell & Son newsagent, a ladies fashions and accessories shop, a florist's, a gift and home-ware shop, a pharmacy, and a sandwich shop and courtyard café.

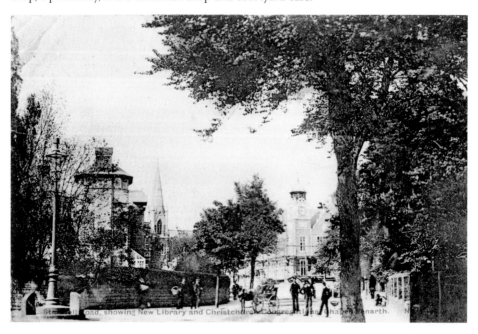

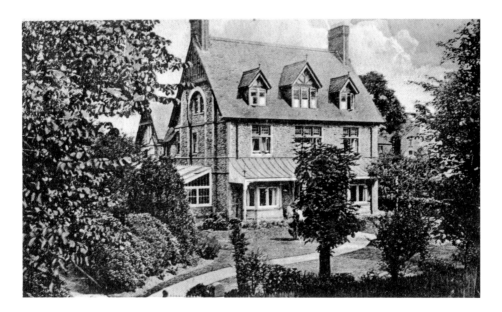

## The College

Penarth Tutorial College opened in Albert Crescent during the 1880s, moving to 9 and 10 Stanwell Road in 1905 and then to Westwood House, where it became Westwood College in 1922. Westwood College closed in 1944 and the building nowadays holds the Penarth Conservative Club. Ebenezer House on Westbourne Road, Penarth, was renamed Westbourne House Preparatory School for Boys. In 1901 the school relocated to the large corner property at 13 Stanwell Road, and in 1975 the adjoining property at 4 Hickman Road was also purchased. The combined properties were developed as Westbourne Senior School. St Alma's Girls School located in Victoria Road was purchased, and the combined school became co-educational.

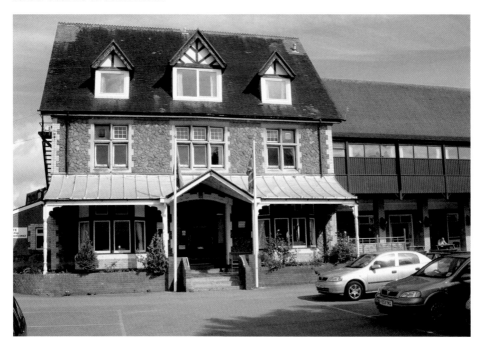

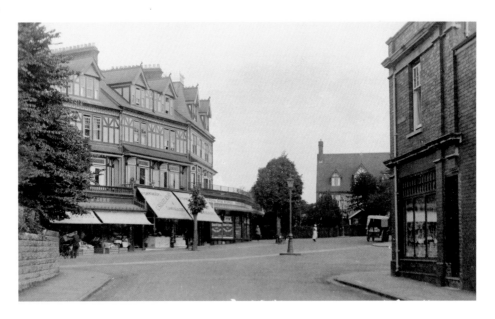

## Royal Buildings, from Stanwell Road

Royal Buildings seen here from Station Approach. They were built by Frederick Speed, who also built the British Legion in Station Approach, Lansdowne Hotel and Beachcliff. The Royal Shoe Stores, C. Sadler & Sons the fishmongers and Sadlers the fruiterers can be seen on the left, whilst a delivery cart is parked outside Woodward's Royal Stores on the other side of the road. On the corner was Richards' Royal Pharmacy. Just out of shot is the Paget Rooms, built in 1906 to designs by John Coates Carter (who also designed Westwood House and All Saints' church). In the 1930s it became the Willmore Brothers' Regal Cinema. Not a success, it became a public hall and a popular dance hall.

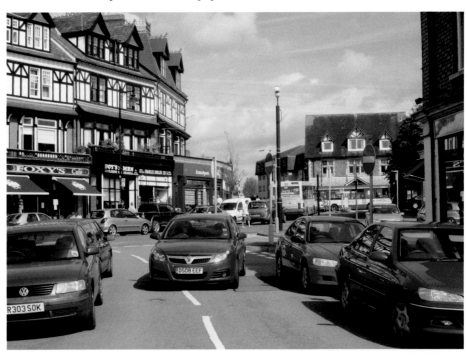

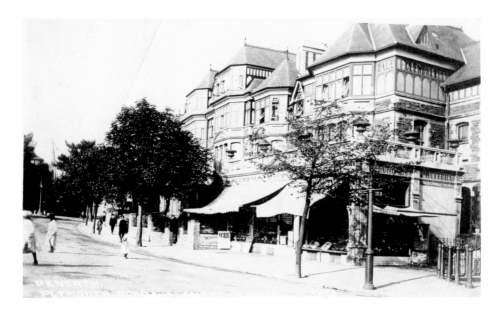

## Plymouth Road

The Lansdowne block of buildings opposite the railway station in Plymouth Road was built in 1886 by Frederick Speed. The Lansdowne Hotel, in the middle of the block, was very convenient for the station and was therefore much more viable than the Penarth Hotel, located near the Docks. Now it is Lansdowne House, which has been converted into flats, with the Glendale Hotel and Villa Napoli restaurant alongside. In 1880 James Pyke-Thomson, who had made his fortune in flour, built his house, Redlands, in Plymouth Road. The brewer S. A. Brain bought Redlands in 1899 and renamed it Roxburgh, and then in 1910 he sold it to the shipping magnate Thomas Morel. Roxburgh Garden Court that now occupies the site consists of twenty residential houses.

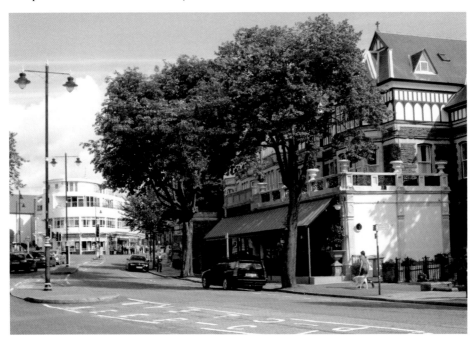

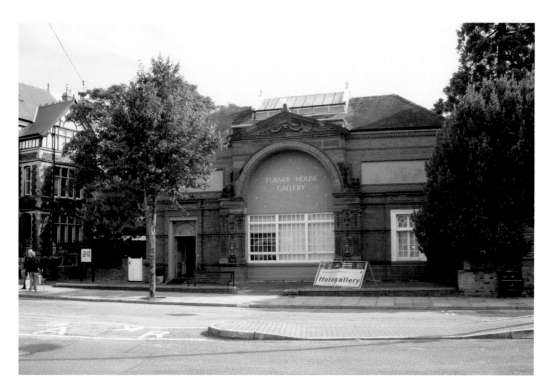

## Turner House Gallery

In 1888 Pyke-Thomson opened Turner House Gallery (named after the painter J. M. W. Turner) on the corner of his land at the entrance to the dingle leading down to the beach. Turner House was slightly structurally modified and re-opened in 1950, where it continued exhibiting shows organised by the National Museum of Wales until 2003, when Ffotogallery took over responsibility for programming exhibitions and administering gallery-based educational activities.

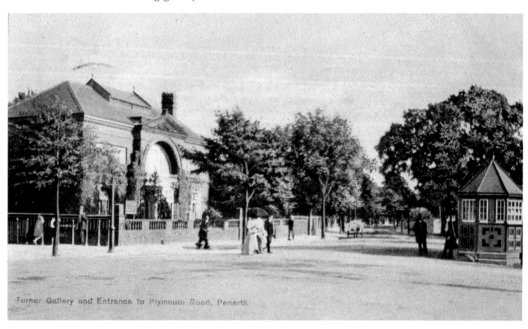

Turner Gallery and Entrance to Plymouth Road, Penarth

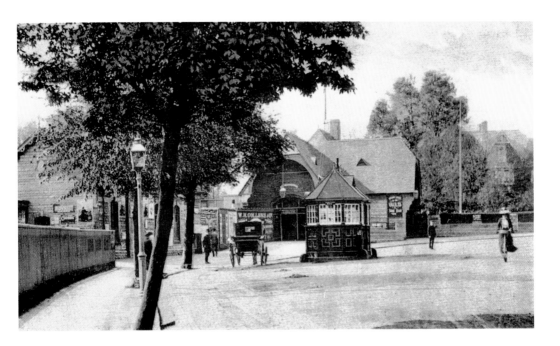

## Railway Station

Penarth Railway Station, with the octagonal shelter for drivers of horse-drawn cabs outside the main station entrance. The cabs ran from the station to the esplanade via Beach Hill, usually returning along Marine Parade to make a wide circular run. In 1878 Penarth Railway Station consisted of only one platform on the Plymouth Road side. In the first week the railway opened nearly 4,000 people travelled. The staff numbered sixty-three in 1923, falling to thirty-nine in 1938. The suffix 'Town' was used until 1962. The Railway Hotel was built next door to the station on the corner of Plymouth Road and Stanwell Road. The Charnwood House block now contains the Job Centre, with Drake House alongside.

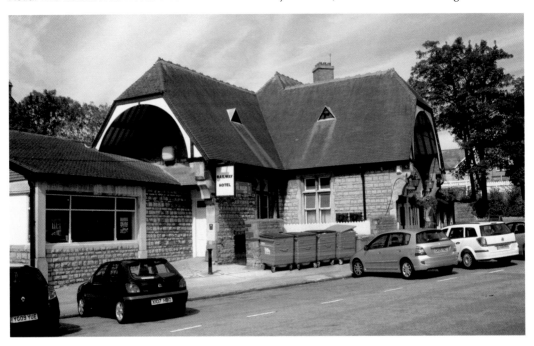

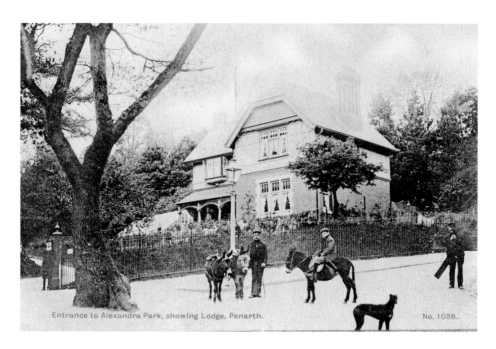

Entrance to Alexandra Park, showing Lodge, Penarth.    No. 1036.

## Alexandra Park Lodge

Alexandra Park was opened in 1902, with colourful flowerbeds, an ornamental fishpond, an ornate bandstand and the town's Cenotaph memorial to the fallen of two World Wars. The park leads from the town down to the seafront, almost connecting up with Windsor Gardens that runs above and parallel to the esplanade. Here we see the Alexandra Park Lodge at the southern end of the park in Beach Road

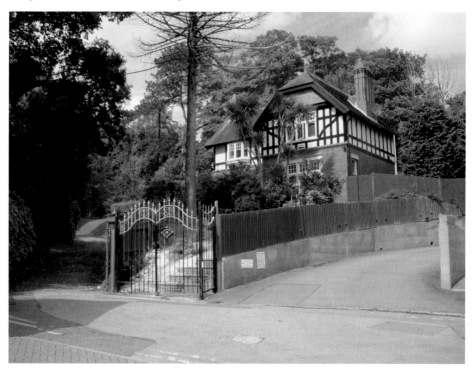

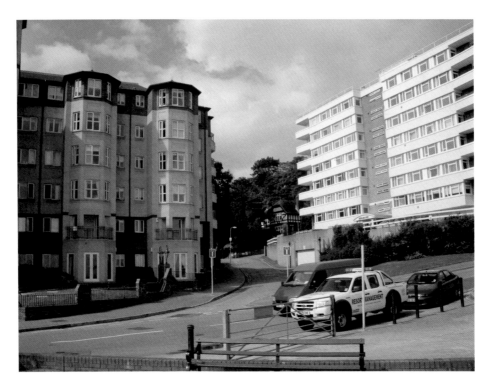

## Donkeys

At its foot Beach Hill turned right, and entry onto the beach was made alongside the park lodge where the park superintendent lived. The present curve left and then right was made in 1924. Donkeys were worked along the narrow strip of shingle between the pier and the Yacht Club when the tide was out, and along the promenade when the tide was in. Seabank Flats now occupy the land to the right, with Alexandra Court to the left.

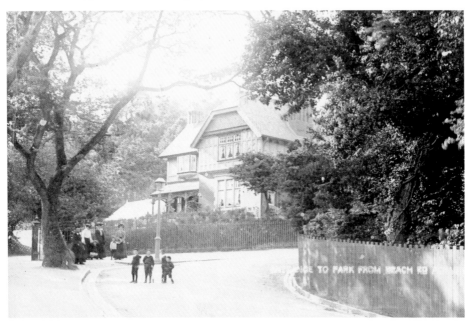

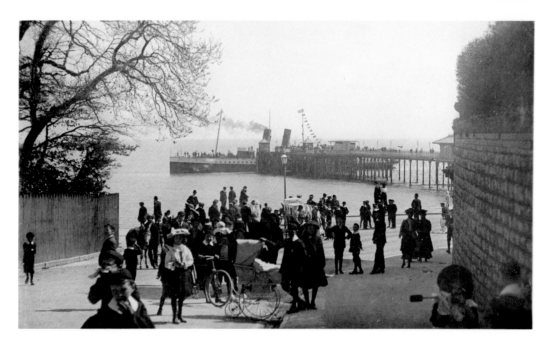

## A Busy Corner

This 1907 postcard produced by H. Woodward (Noah's Ark, 6 Windsor Road), shows a 'busy corner' at the bottom of Beach Hill next to the Esplanade Hotel. The paddle steamer is the Barry Railway Company's *Devonia*. The 2009 view has a Resort Management vehicle parked in front of Alexandra Court. Note that the former paddling pool is now a flower bed.

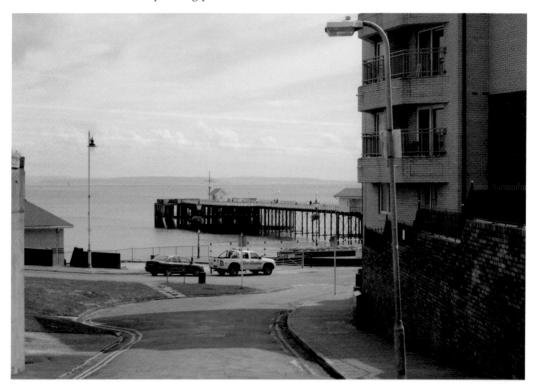

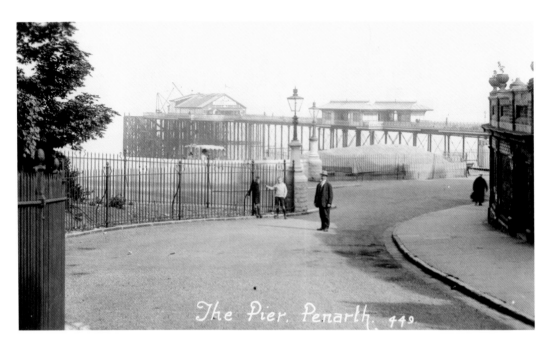

The Pier, Penarth. 449

## Alongside the Esplanade Hotel

A much quieter scene is found in this Viner postcard (dated 1925). The message reads 'This is a picture of the new road and the work going on at the pier, the new road goes up the other side of the railings you see'. This new route opened in 1924 and the pier was acquired by Penarth Urban District Council in the same year. Seabank Flats now offer panoramic views overlooking Penarth Pier and the Bristol Channel, with spacious studio apartments and off-road parking.

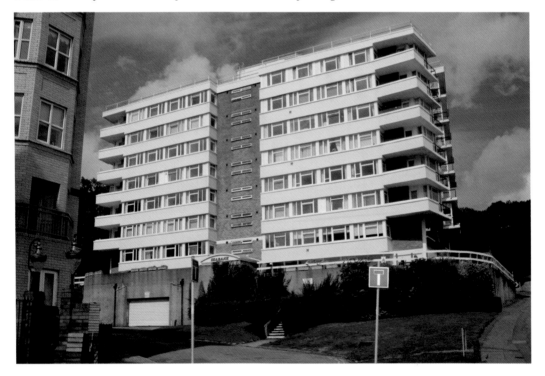

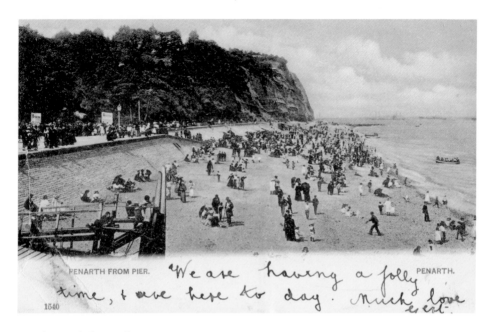

PENARTH FROM PIER.   We are having a jolly   PENARTH.
time, + are here to day. Much love
1540

### North Beach from Pier

This postcard, dated 1902, shows the north end of the beach. The refreshment stalls can barely be seen amongst the masses of people enjoying a day at the seaside. A movable stage for the embarking and loading of the ferry passengers is visible in the left foreground. The statement 'THE ADDRESS ONLY TO BE WRITTEN ON THIS SIDE' on the reverse of this postcard forced the sender to squash her message into the small space below the picture. Note how erosion has changed the shape of Penarth Head cliff.

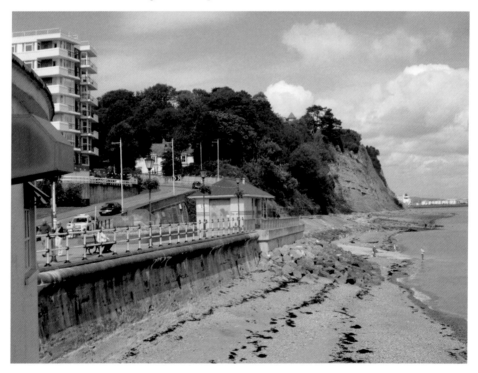

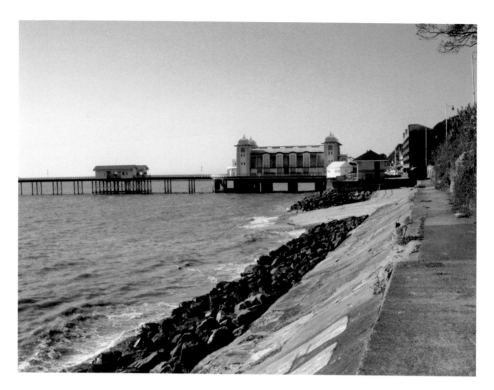

### Refreshment stalls

The north end of Penarth Beach, around 1910, showing the tented refreshment stalls (including Mrs Norman's cockle stall). This area later became known as the Dardenelles, due to the fortifications that occurred during the First World War, which reminded servicemen of Gallipoli. It later became the site of a multi-storey car park, which has now been demolished.

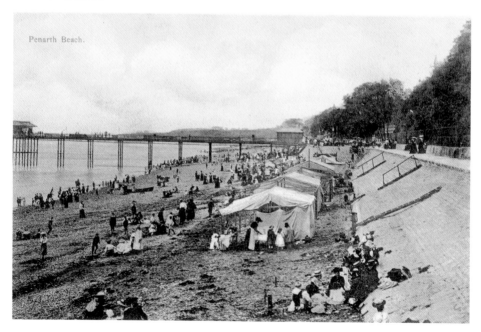

Penarth Beach.

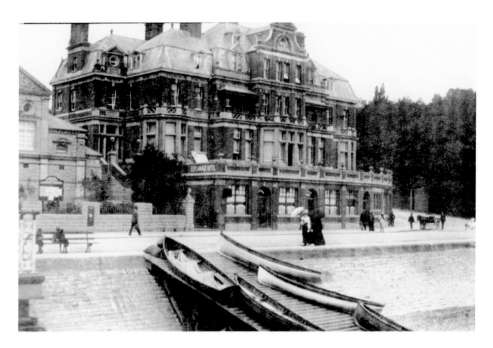

### Esplanade Hotel

The Esplanade Hotel, built of local red brick and Bath stone, opened in 1887. The hotel was convenient for the Penarth Ferry going to the Dock and Cardiff every twenty minutes. It boasted a restaurant with fine wines, a café and ornamental gardens. From 1901 until it closed in 1971, the hotel was also the base for the Barbarian Rugby Club, who played Penarth Rugby Club every Good Friday.

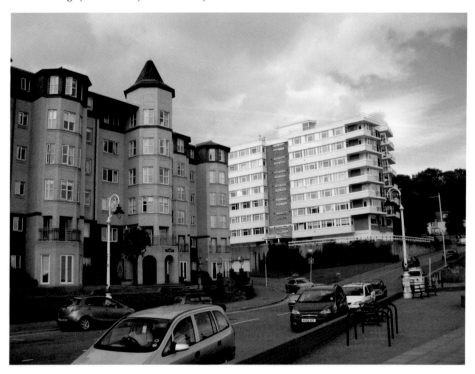

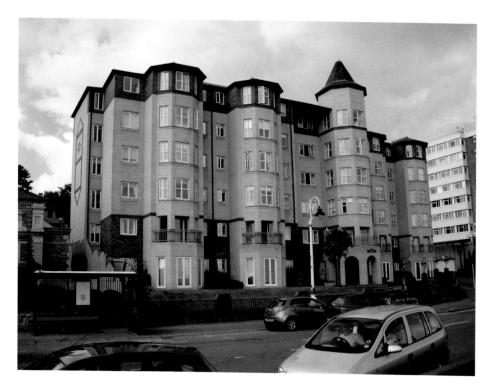

## Alexandra Court

The Esplanade Hotel in all its former glory, before it was destroyed by fire in 1976. Alexandra Court apartments, with a comprehensive gym including solarium and sauna, are now on this site. The views are a big selling point!

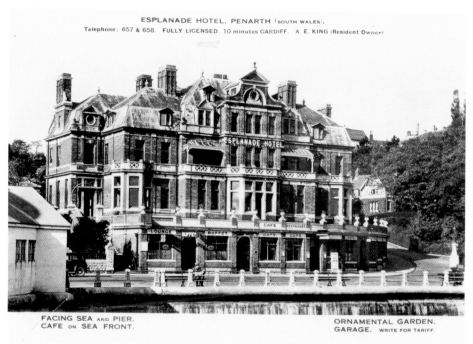

ESPLANADE HOTEL, PENARTH (SOUTH WALES).
Telephone: 657 & 658. FULLY LICENSED. 10 minutes CARDIFF. A. E. KING (Resident Owner)

FACING SEA AND PIER.
CAFE ON SEA FRONT.

ORNAMENTAL GARDEN.
GARAGE. WRITE FOR TARIFF.

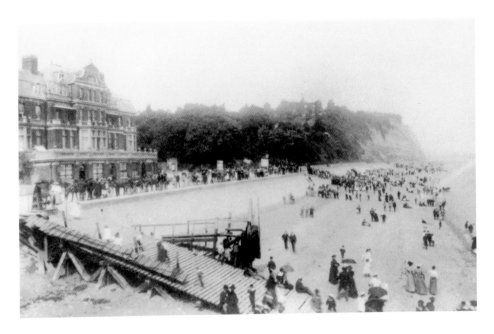

## Slipway

This photograph was taken in 1896 by Francis Frith. It shows a crowded north end of the beach. The movable stages for accessing the ferry are seen next to the wooden slipway. Horse-drawn cabs are lined up opposite the Esplanade Hotel. The 2009 view of the north end of the beach shows the building belonging to Penarth Water Ski Club. Note that the warning sign on the cliff is in three languages.

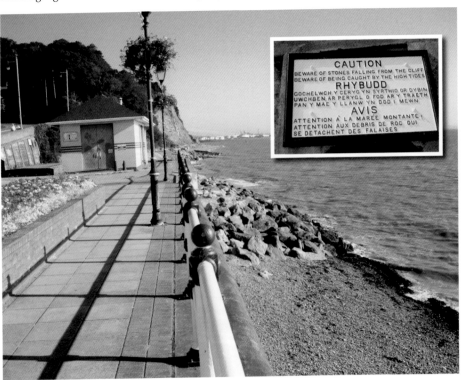

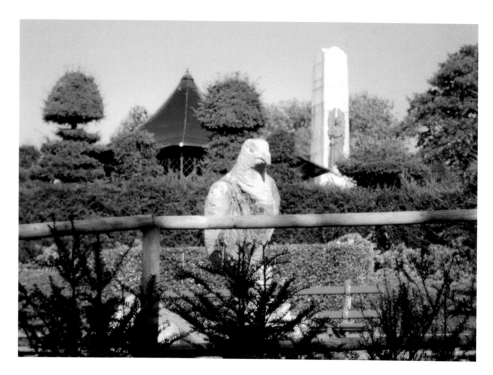

## Alexandra Park

Alexandra Park, named after the wife of Edward VII, was laid out on the land between two dingles and was given to the town by the Plymouth Family. The park opened in 1902. This postcard, dated 1907, shows the bandstand in the foreground, the imposing rear view of the Esplanade Hotel, the cupola and weather vane of the public baths, and the seaward end of the pier before the pavilion was built. Tree growth over the last 100 years now obscures this view. The 2009 photograph shows a carved wooden bird standing guard over the park's aviary, with the bandstand and war memorial in the background. In 1911 the Bristol Zoological Society gave Penarth an eagle, which lived for many years in a cage in the park.

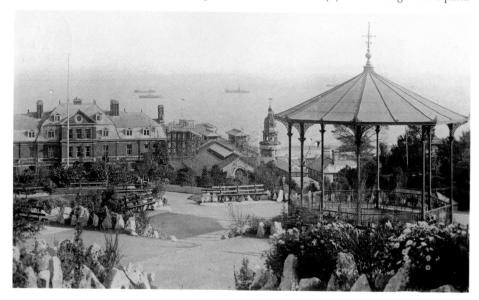

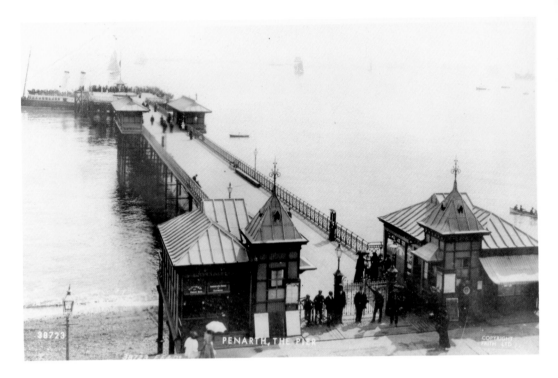

## The Pier

Penarth Pier, one of the last remaining Victorian piers in Wales, was built by the Mayoh Brothers, who also constructed the piers at Brighton (Palace Pier), Great Yarmouth, Morecambe, Mumbles and Weston-super-Mare, and it opened in 1895. By the late 1890s the White Funnel Fleet of Peter and Alex Campbell had taken over the vessels of its competitors, Edwards and Robertson. In 1911 they acquired the Red Funnel Paddle Steamers of the Barry Railway Company, and in 1922 they took over Tucker's Yellow Funnel Fleet. The last two members of Campbell's fleet, *Cardiff Queen* and *Bristol Queen* were withdrawn in 1966 and 1967 respectively.

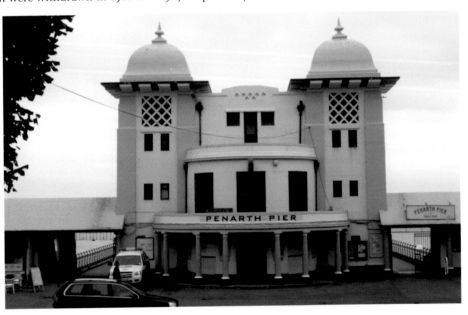

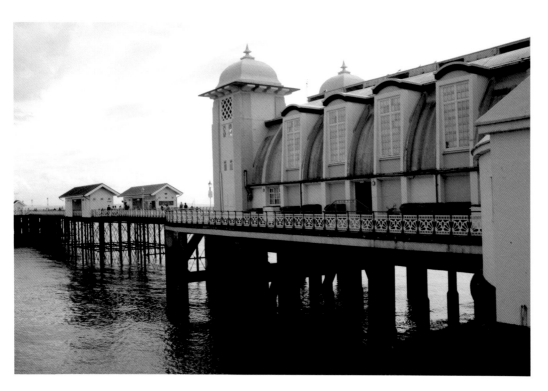

## Bijou Pavilion

In 1907 the wooden Penarth Pier Bijou Pavilion was built on the seaward end of the pier, and acts like the Royal Court Entertainers, Montague's Mountebanks, the Court Jesters and the Mad Hatters featured. Before 1907 all the entertainments held on the pier were held *al fresco*, with temporary canvas awnings being erected if necessary.

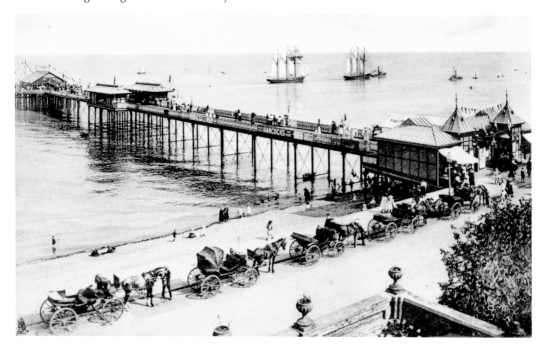

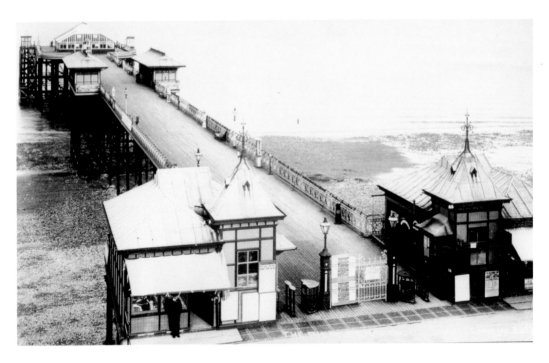

### Pier Entrance

The pier now has a pavilion at the seaward end (therefore after 1907). A poster advertises a concert, and a timetable for the Taff Vale Railway is also posted at the pier entrance. The 2009 view shows Thayers café providing ice cream and hot food and Tony's Pizza shop next to the left-hand side entrance to the pier.

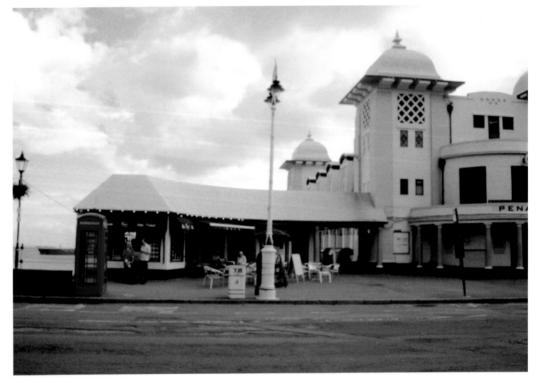

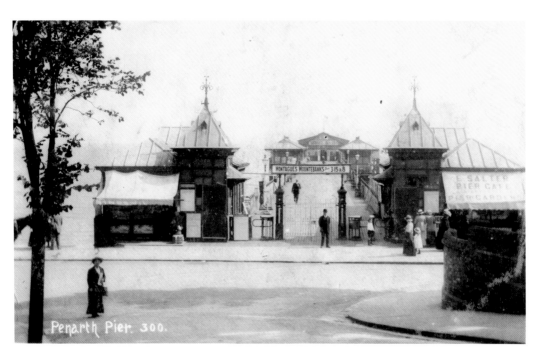

## Pier from Bridgeman Road

Note the ornate, lead-covered rooves of the pier entrance and turnstiles (entrance was 2d). E. Salter's Pier Café occupied the right-hand shop, offering ice cream, with his Tea Gardens behind. The 2009 view shows the right-hand side entrance to the pier, with the Tourist Information Centre and the other Thayer's café alongside.

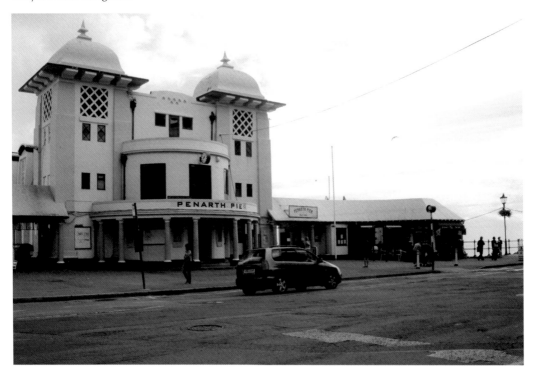

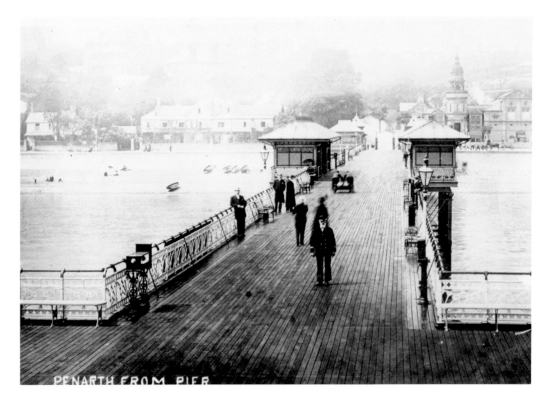

## Piermaster

The piermaster is shown walking along an almost deserted pier in this card, dated 1906. The horse-drawn cabs can be seen lining up outside the baths. Rowing boats are stored on the pebble beach in front of Rock Villa. The 2009 view shows the two kiosks halfway along the pier providing public toilets and takeaway food and drink.

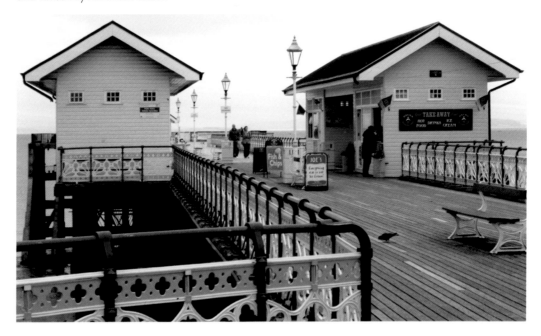

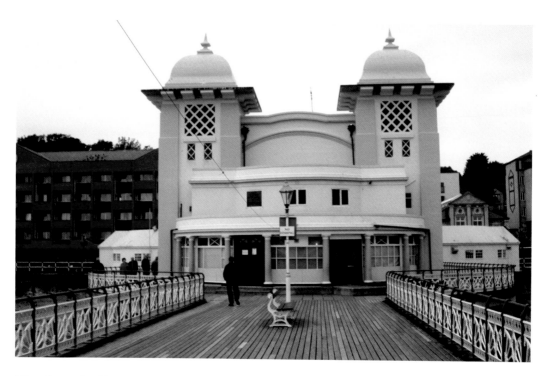

### View from the Pier

This postcard, dated 1914, taken from the pier itself, shows the Esplanade Hotel, the baths and Rock Villa. The 2009 view shows the rear of the concrete pavilion. During its history it has functioned as a cinema (Pavilion Cinema, 1932-3), a dance hall (Marina, 1934), a club and restaurant (Commodore), a snooker club and a gym hall.

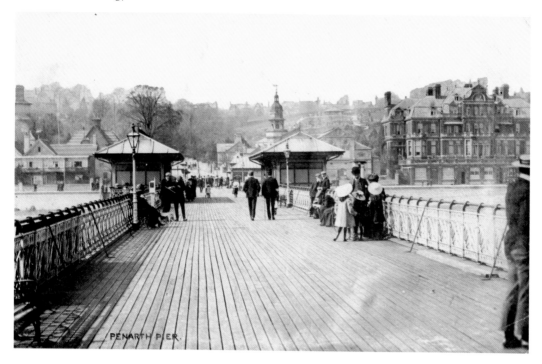

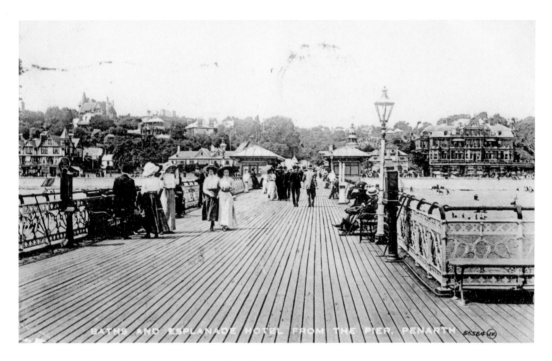

## The Baths and Esplanade Hotel from the Pier

The view from further along the pier in this postcard, dated 1925. In 1929 the pier was given a new landing stage and pavilion at the shoreward end. In 1931 a fire spread almost the entire length of the pier causing serious damage; the pier was rebuilt but the wooden sea-end pavilion was never replaced. The apartments of Alexandra Court, on the site of the Esplanade Hotel, are named after the vessels which comprised the P. & A. Campbell fleet — *The Britannia, Cambria, Ravenswood, Glen Avon, Glen Gower, Devonia* and *Glen Usk*.

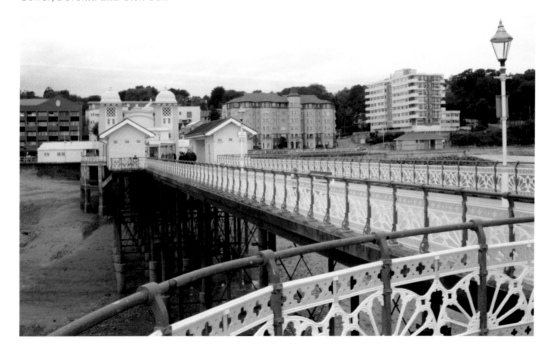

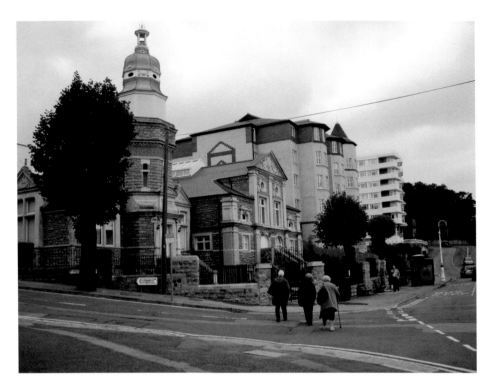

## The Baths

This postcard has a view taken from outside the public baths, at the bottom of Bridgeman Road, which was named after Lady Selina Bridgeman, daughter of the Earl of Bradford, who married Robert Clive in 1852. In 1885 the Penarth Public Swimming Baths, with an octagonal tower and cupola surmounted by a dolphin, were opened. Initially the baths were fed by salt water from two reservoirs in Alexandra Gardens, sea water being pumped up from the Bristol Channel at high tide. Only later did the baths turn to fresh water.

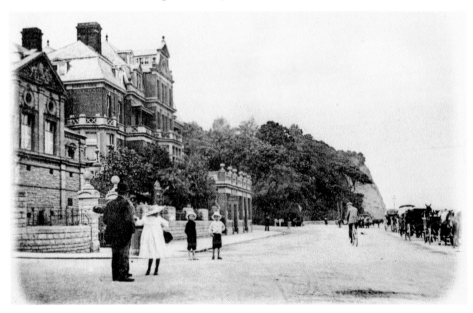

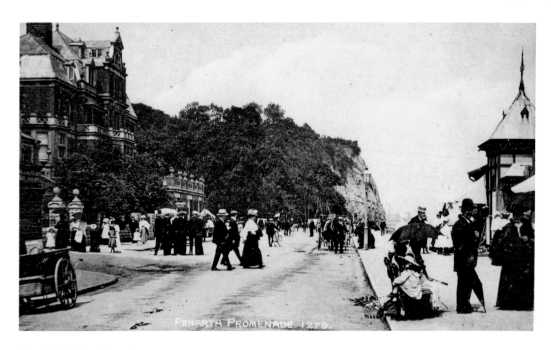

PENARTH PROMENADE 1279.

### The Baths Continued

The larger of the two pools was seventy-nine feet long, the smaller one just fifty-two feet. Mixed bathing was not allowed until 1928. Hot and cold slipper baths were available and the larger pool could be boarded over and used as a gymnasium or roller-skating rink. The baths were closed in the 1980s after Cogan Leisure Centre opened, and the building became The Inn At The Deep End, a pub and restaurant, for a while. It has recently been tastefully converted into luxury flats, while retaining its Victorian exterior.

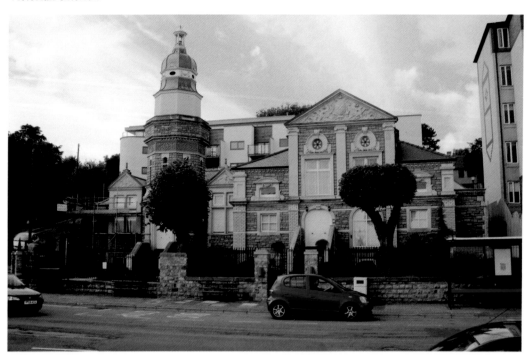

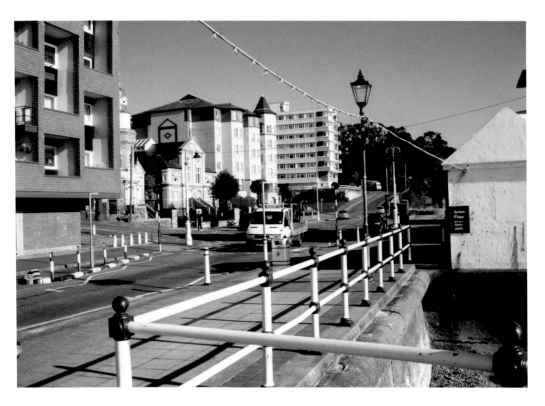

## Pavilion Construction

This postcard dates from before the Art Deco-style concrete pavilion opened on the landward end of the pier in 1929 for concerts and dances. You can see the construction beginning in the right of the photograph. The 2009 view shows the same approach to Beach Hill, but the buildings have changed dramatically.

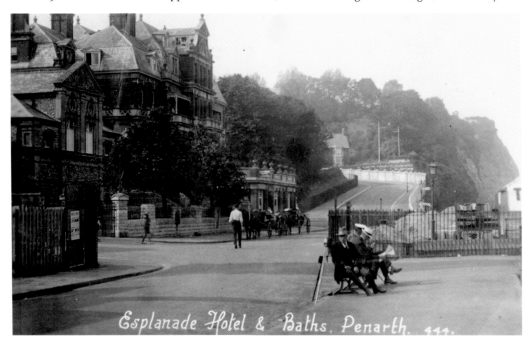

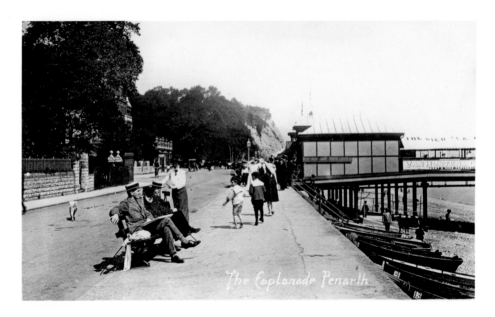

The Esplanade Penarth

## Pier Tea Gardens

This postcard, dated 1911, shows the Pier Tea Gardens at the shore end of the pier. 'Van Houtens Cocoa – the best goes farthest' is advertised on the side of the pier. Balcony and Rock Villas are just out of shot to the left, whilst numbered rowing boats can be seen to the right, on the beach next to the wooden steps. The Cardiff Bay Development Corporation agreed to fund the complete restoration and refurbishment of the esplanade. One major improvement was the restoration of the exterior of the pier's pavilion building, completed in 2006, and the beautiful ornate lamp pillars from the 1920s on the esplanade were expertly restored.

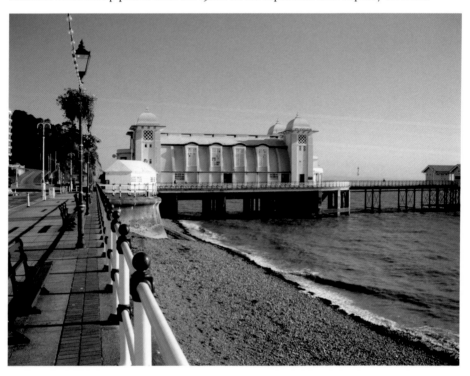

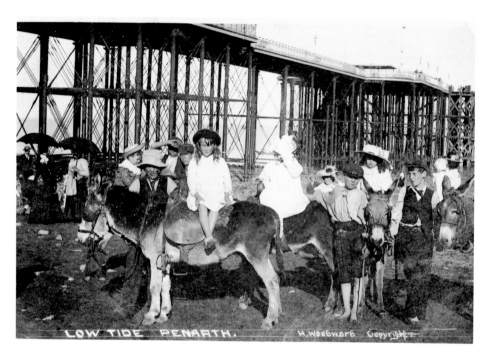

## 'Donkey Island'

In 1899 the following had donkey licences: James Buckland, Charles Harwood, Sarah Vizard, Albert Brooks, James and Frederick Matthews. These animals earned Penarth the nickname 'Donkey Island'. Rides were given along the sandy strip between the pier and Yacht Club landing stage or from near the Park Lodge to Bridgeman Road if the tide was in.

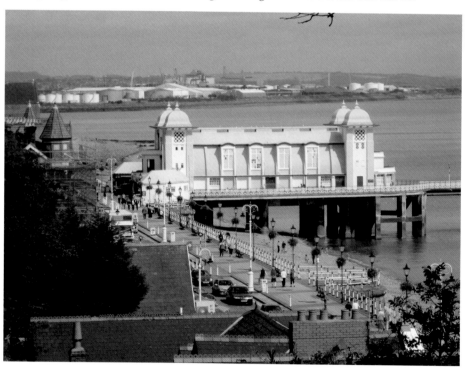

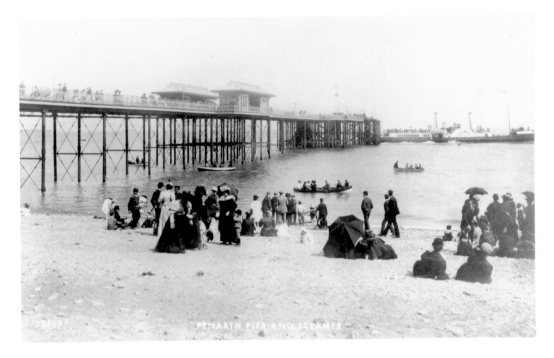

PENARTH PIER AND STEAMER

## Paddle Steamers

Here we see the rowing boats in the sea, with a paddle steamer just leaving the pier. Nowadays the MV (Motor Vessel) *Balmoral*, the UK's widest travelled excursion ship, and PS (Paddle Steamer) *Waverley*, the last sea-going paddle steamer in the world, bought for £1 in 1974 by The Paddle Steamer Preservation Society, still provide pleasure cruises calling at Penarth Pier during the summer. The 2009 view shows the *Balmoral* leaving the pier.

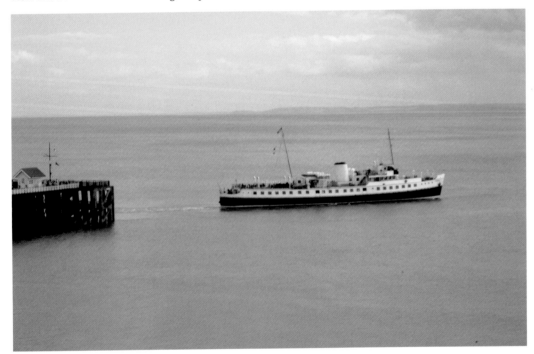

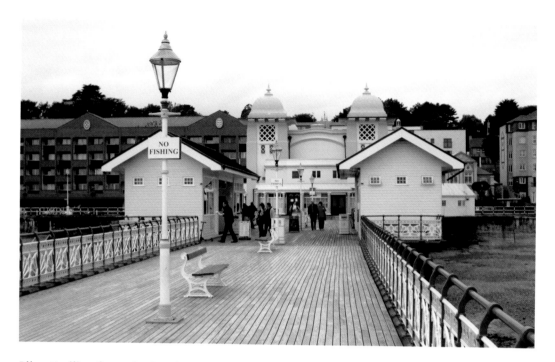

## Bijou Pavilion from the Beach

The foundations of the esplanade were first laid in the early 1880s using the rocks cut out of the cliff during the construction of Cliff Hill. It was originally thirty-six feet wide and gave access to the beach via ramps at either end and flights of wooden steps along its length. It proved extremely popular and visitor numbers increased dramatically, so that by 1910 it was becoming dangerously congested, especially at holiday times, and plans were drawn up to widen it by extending over the foreshore.

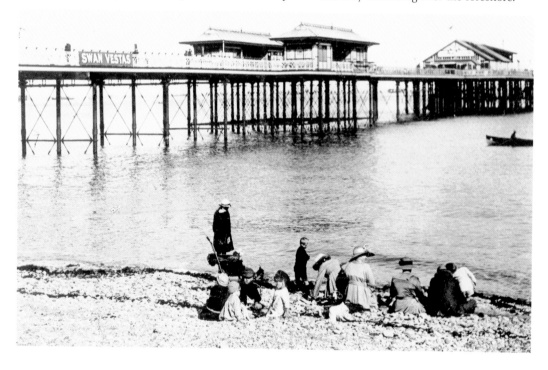

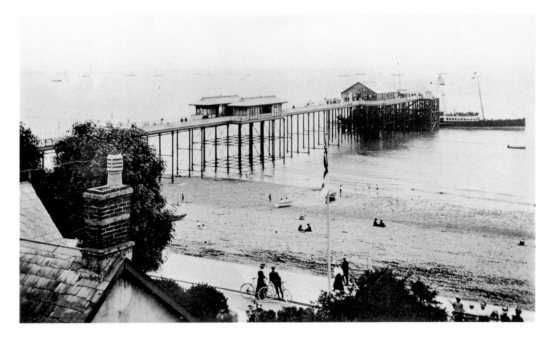

### The Pier from Windsor Gardens

Here we have a shot taken from Windsor Gardens. Windsor Gardens were designed by Robert Forrest and Henry Snell as a cliff-top garden overlooking the Bristol Channel, laid out behind the grand houses on Bridgeman Road and Marine Parade, whose residents were offered private entry gates for half a guinea. A 1d entrance fee via a turnstile next to the Piermaster's Lodge, opposite the baths, was available for the public. The 2009 view shows the *Balmoral* at the end of the pier.

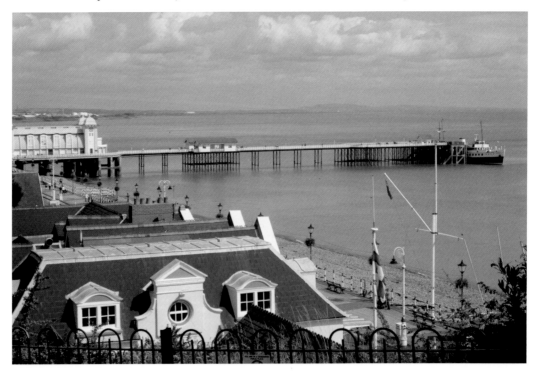

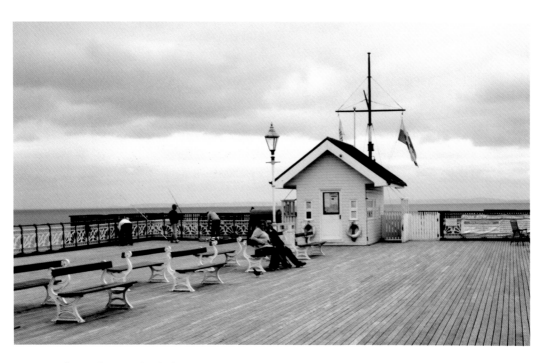

### The Pier from the Beach Shelter

In the mid-1920s the esplanade was widened to sixty feet and a new curved sea wall constructed. New railings were also erected and new seats installed, and the esplanade was finally formally re-opened with much pomp and ceremony on Empire Day, 24 May 1928. The 2009 view shows anglers and the kiosk at the end of the pier.

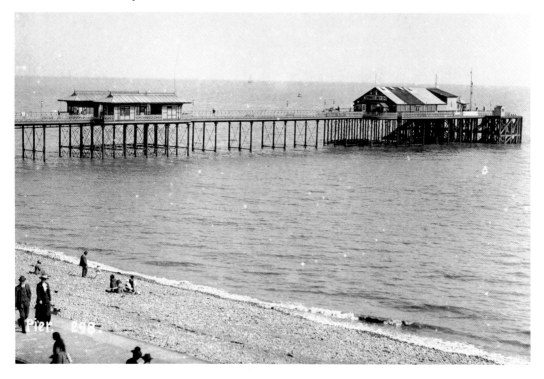

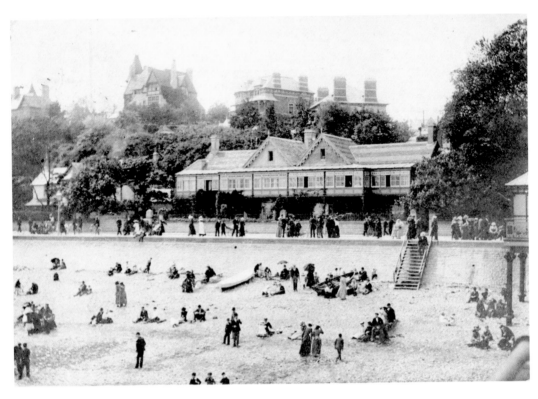

**Rock Villa and Balcony Villa from the Pier**

Rock Villa and Balcony Villa were built on the promenade in the 1860s. Both the villas had an enclosed balcony running their entire frontage at first floor level. Both were demolished in 1963, and Windsor Court flats were built on the site. Steamers Trading is situated on the ground floor, selling traditional toys and dolls, a host of curios and ornaments, sofas and chairs, and Welsh souvenirs.

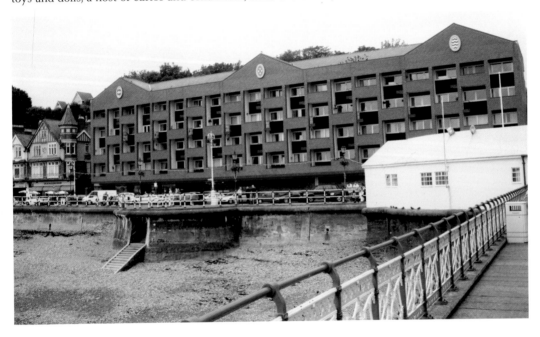

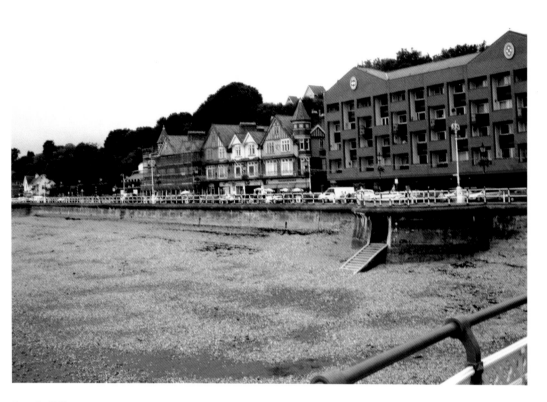

## Beachcliff

This postcard shows Beachcliff with its decorative iron balustrades and a tower at both ends. The lower floors of these terraced buildings are now restaurants: Rabaiottis, Morgans Fish & Chips, Café R at the Beach and Chandlers Wine Bar (which has living accommodation above).

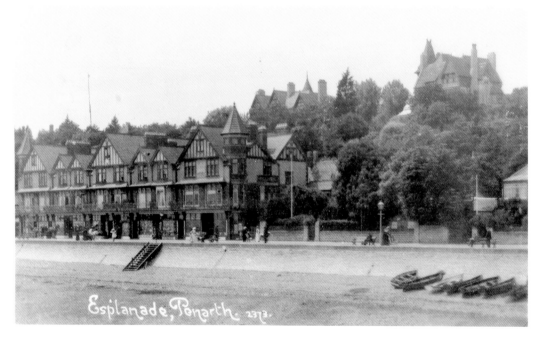

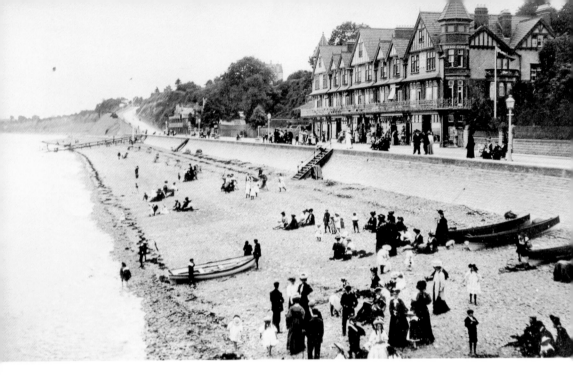

## The Beach

This Edwardian terrace, known as Beachcliff, was designed and built by Frederick Speed in 1904. The block had private hotels at each end, with the Gwalia Café and Beach Cliff Private Hotel situated at the southern end, the Cabin shop in the middle, and Govier's restaurant at the northern end. The 2009 view has scaffolding and netting obscuring Beachcliff.

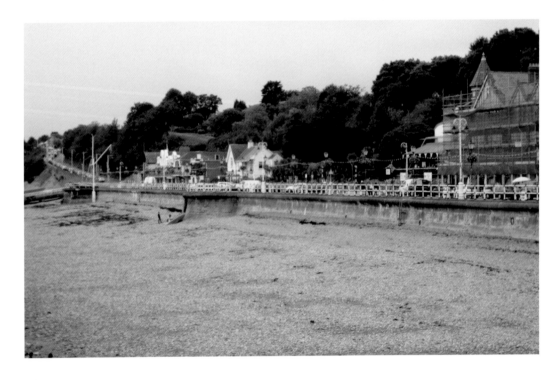

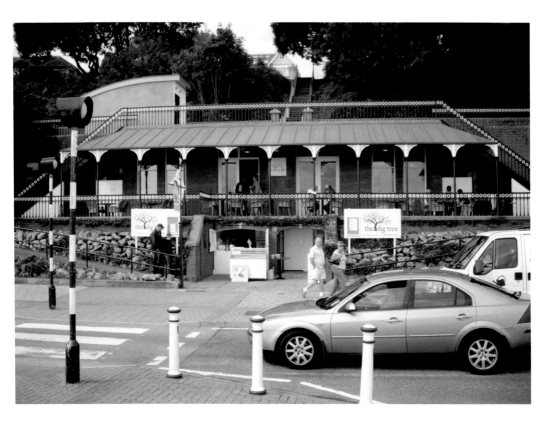

### The Esplanade from the Beach

From the steps leading to the beach from the promenade is a chain where boats are tied up. The notice on the top of the sea wall marks that this boat area was reserved for the Pier Company. The 2009 view shows the Fig Tree Restaurant, which opened in the summer of 2009.

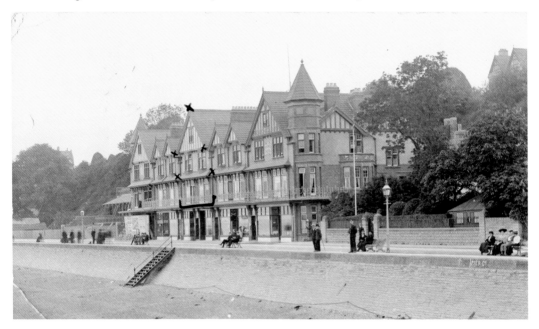

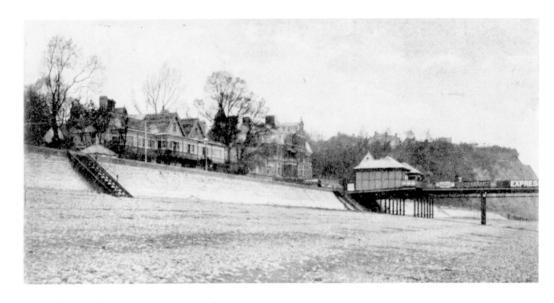

## Cross Channel Swim and Hovercraft

Twenty-year-old Kathleen Thomas became the first person to swim across the Bristol Channel, from Penarth to Weston-super-Mare in 1927. The distance is only twelve and a half miles but the tidal flow in the Channel caused Kathleen to swim twice the distance taking seven hours and twenty minutes. It was not until 1970 that someone (Bill Pickering) swam the Channel both ways. In 1963, from 23 July to 30 August, the twenty-seven ton experimental hovercraft SR-N2 (Saunders-Roe Nautical Two) carried out passenger flights between Penarth and Weston-super-Mare operated by Campbell's. The 'flight' took just twelve minutes, and the author remembers it as a very bumpy journey with spray obscuring the view!

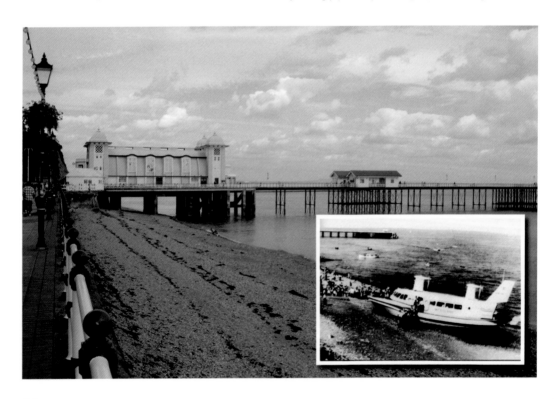

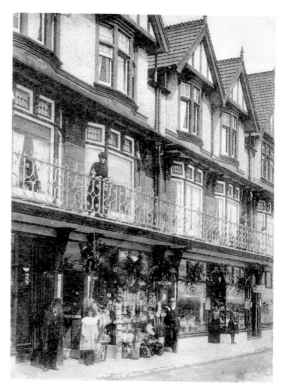

## The Cabin

This card gives a closer look at the shops in the Beachcliff block. Here we see the Cabin selling everything you need for a day at the seaside. To the left was Govier's Restaurant, whilst on the far right is a sign for the 'Public Telephone Call Office'. At the far right end of the block was Beach Cliff Private Hotel. In 2007 Beachcliff was purchased from the Rabaiotti family, with a formal planning application approved in March 2009 for the refurbishment of the building to provide seven luxury flats and a gymnasium facility on the ground floor. The 2009 view shows Chandlers (behind the scaffolding), Café R at the beach, Morgans restaurant and Rabaiottis.

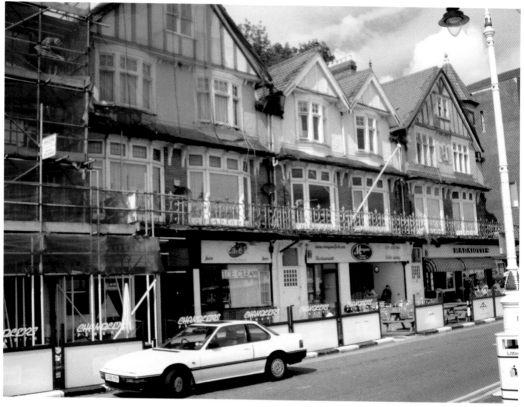

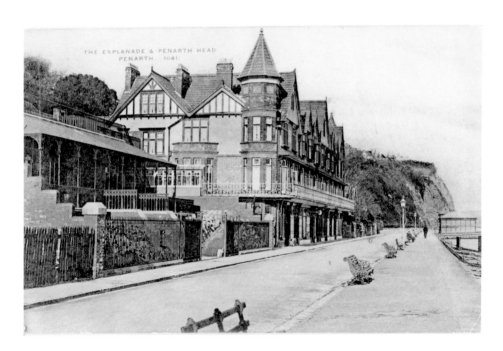

## Beach Shelter

The beach shelter ran as Refreshment Rooms and Bazaar, before becoming the Penarth Shelter and Pavilion in the 1900s. The idea for a garden came from the first female chairman of the council (1924-25), Mrs Constance Maillard. The garden was based on plans and planting proposals drawn up by Miss Ursula Thompson, who was the first woman to graduate as a gardener from Kew Gardens. Miss Thompson had worked in Italy restoring classical gardens. The Fig Tree Restaurant opened in Summer 2009.

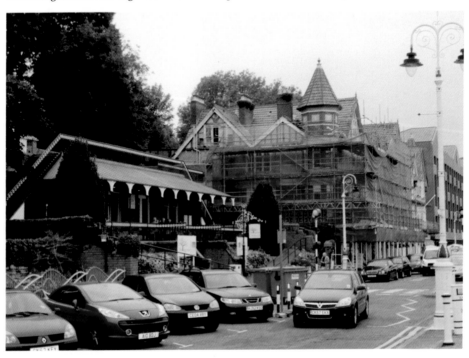

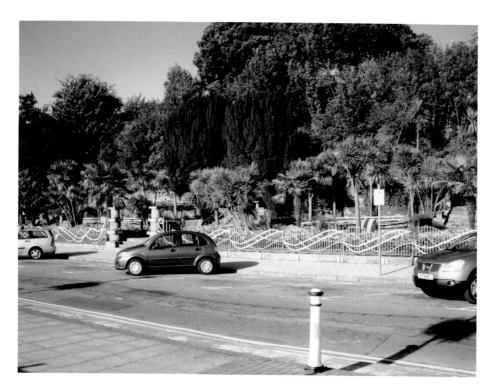

## The Italian Gardens

The gardens were opened in March 1926 but were first named the Beach Rock Gardens, the New Rock Garden, or the Promenade Garden, the name Italian Gardens being adopted later. Palm trees and a large fig tree on the south wall give the gardens a tropical feel and the beds are filled with magnificent floral displays through the summer months. The entrance steps are flanked by two yew trees and a large plaque situated centrally at the top of the steps commemorates the visit of Diana, Princess of Wales, to Penarth in October 1991. New wave-design railings were installed in 1994.

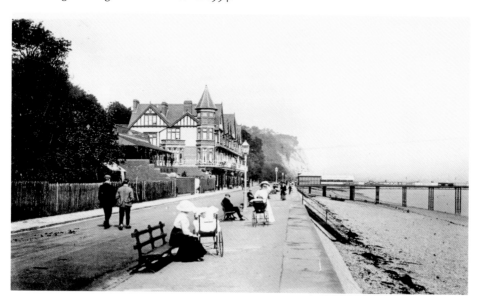

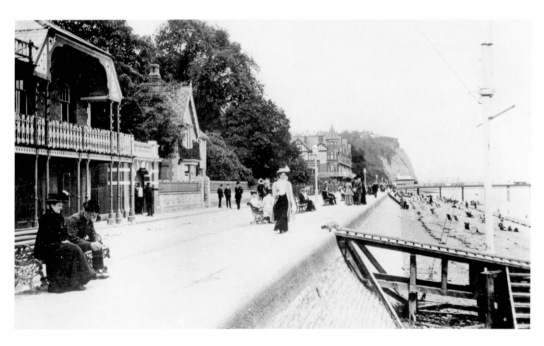

The Waters Edge

The Seacot Hotel has been taken over by the proprietors of the Mediterraneo restaurant and renamed The Waters Edge.

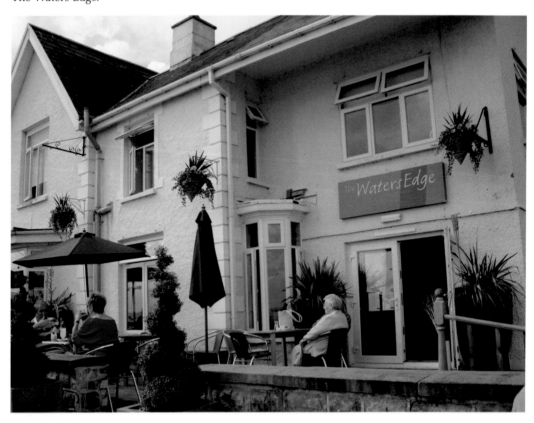

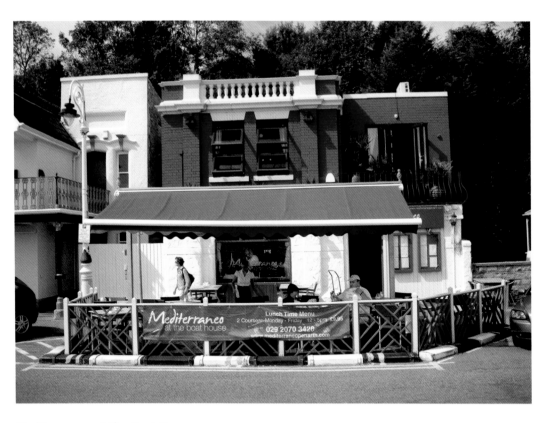

**Mediterraneo at the Boat House**
Originally built by the Admiralty as a boathouse in the grounds of Seacot at the turn of the century, Mediterraneo at the Boat House is now an Italian and seafood restaurant.

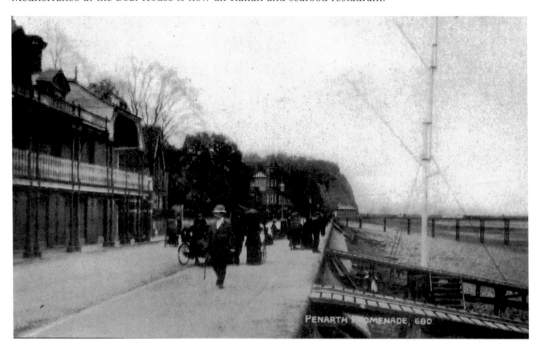

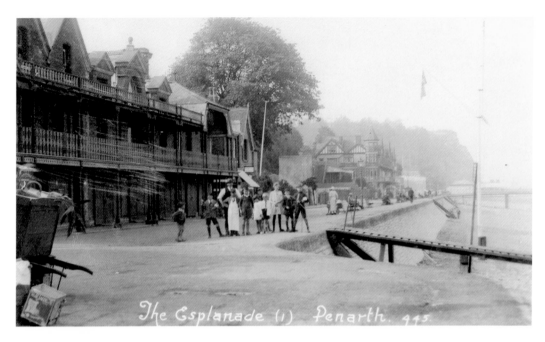

The Esplanade (1) Penarth. 445.

### The Yacht Club

A group of children and one gentleman (who has perhaps temporarily rested his cart, left foreground) pose in front of the Yacht Club. Penarth Yacht Club was originally named Penarth Boat Club, it changed its name in 1895. The impressive Yacht Club building was constructed in three phases in 1884, 1885 and 1905 and its slipway, seen here next to the flagpole, was built at the same time as the esplanade in 1883/4.

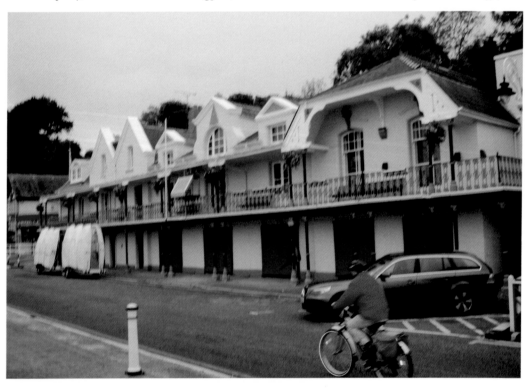

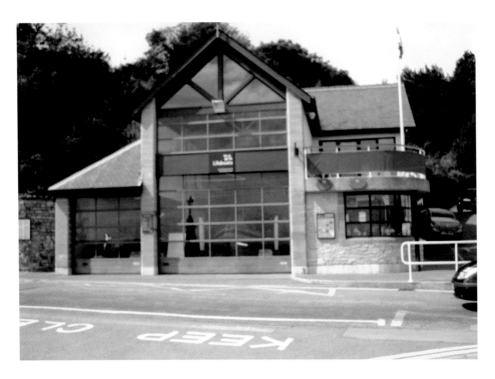

## The Lifeboat Station

In 1861 the RNLI established a lifeboat station and a boathouse next to the path leading down from Marine Parade (where the Yacht Club is today). A larger lifeboat was delivered in 1881 which was too large for the building, so a new building was constructed close to the Custom House under Penarth Head. In 1905 the lifeboat was withdrawn from service, and the lifeboat station closed when other stations at Barry Dock and Weston-super-Mare opened. In 1980 the station reopened as an inshore lifeboat station, and in 1995 a new boathouse and slipway were built to house a B-class lifeboat and launching vehicle, a workshop, souvenir sales outlet, oil and petrol stores, and improved crew facilities.

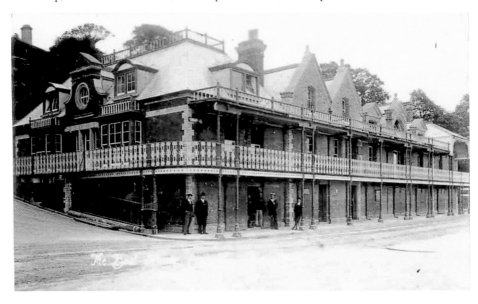

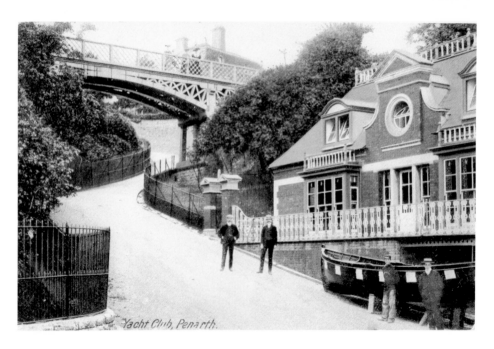

Yacht Club, Penarth.

**The Fire Boat**

This postcard, dated 1907, shows the bridge joining the two parts of Windsor Gardens. At the right of the bridge, behind the bushes, was a 'puzzle gate', where people could leave the gardens — having paid their entrance fee at the Bridgeman Road entrance — but not enter. The large boat was a 'fire boat' used in regattas, with the white squares representing gun ports.

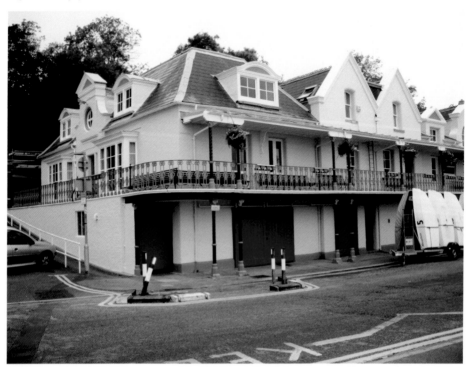

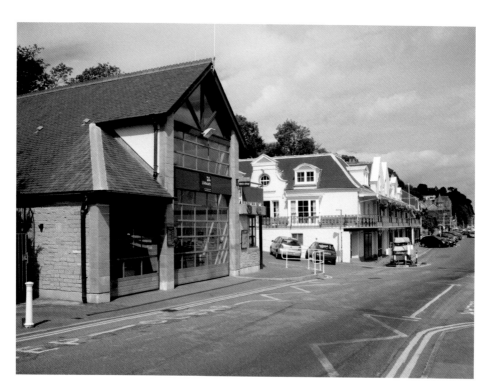

## The Old and New Lifeboat Stations

This very early photograph of the beach shows Sea Cot and the lifeboat station, and further along Balcony and Rock Villas, before the Yacht Club, pier, Esplanade Hotel or the esplanade itself were built. The 2009 view shows the modern lifeboat station alongside the Yacht Club.

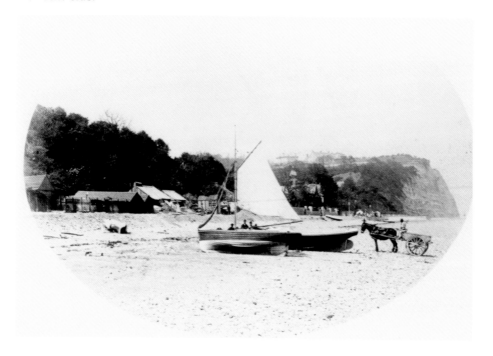

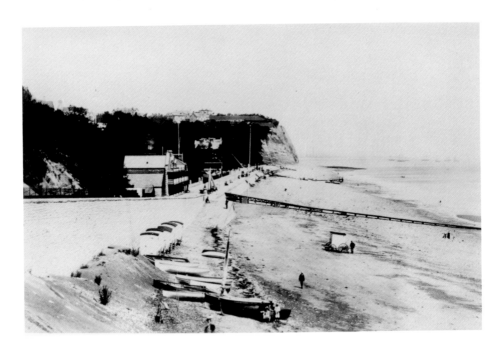

## Cliff Hill

This slightly later photograph (but still no pier!) shows bathing machines and rowing boats placed in the shelter of Cliff Hill. During the winter the bathing machines were stored near Beach House, where the present Italian Gardens are. The ferry landing stage is seen at the far end of the beach. The ferry boats *Kate, Iona* and *La Belle Marie* ran every twenty minutes from Cardiff Pier Head to Penarth Dock and Penarth Beach.

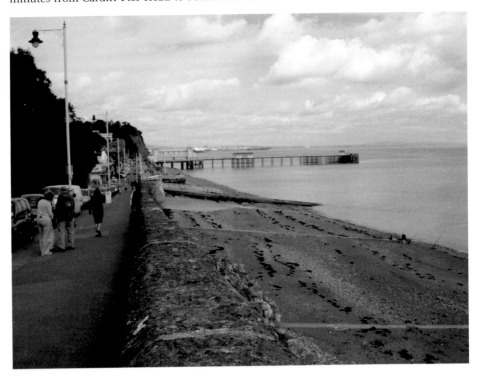

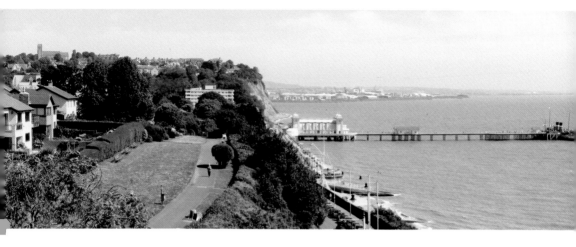

## Bathing Machines

This scene, dated 1903, shows the south end of the beach, under the protection of the sea defence wall of Cliff Hill. In the foreground are the horse-drawn bathing machines, ready to take their occupants to the water's edge. A paddle steamer is just leaving the pier, the Bijou Pavilion yet to be built. The modern view shows the Waverley at the end of the pier in this Vilis Kuksa photograph, which was taken using a seventy-foot telescopic mast system with digital camera remotely controlled from the ground via a laptop computer.

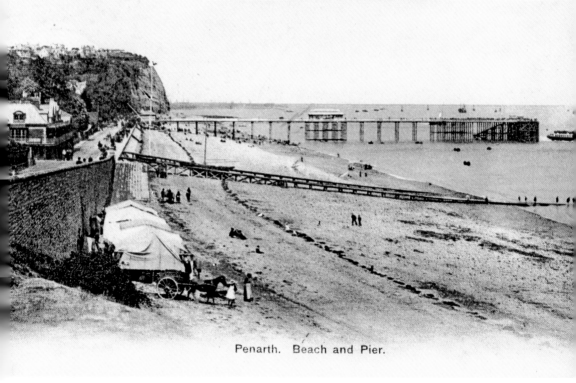

Penarth. Beach and Pier.

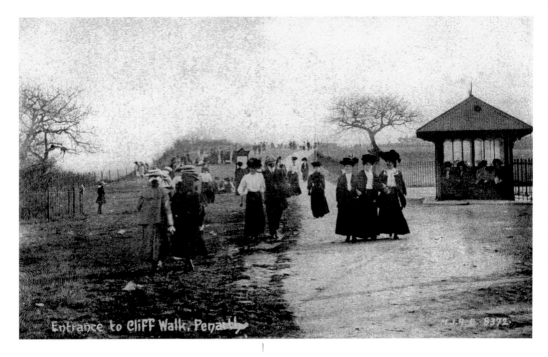

Entrance to Cliff Walk, Penarth

## Cliff Walk

This postcard shows people strolling by and others using the shelter at the Cliff Road Entrance to Cliff Walk. Comparison with a similar view today shows how cliff erosion has resulted in the movement of the cliff fence a great distance inwards. Paris-born Impressionist Alfred Sisley, a friend of Monet, painted some dramatic seascapes during his 1897 visit to Penarth. These included The Cardiff Shipping Lane, painted from a cliff top vantage point in Penarth, looking back towards the pier. The modern panoramic view is by Vilis Kuksa.

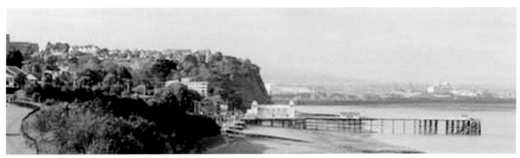

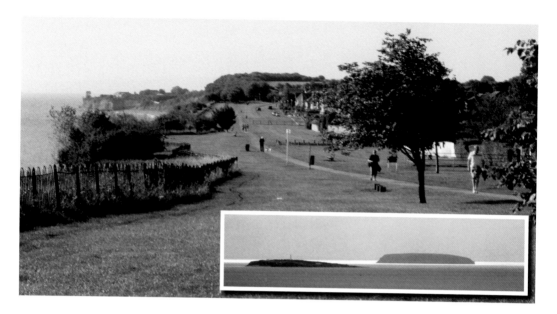

## Lavernock Point, Flat Holm and Steep Holm

Here we see another busy Cliff Walk scene. Guglielmo Marconi successfully transmitted a radio message across water for the first time on 11 May 1897. The transmitter was on the Flat Holm, and the receiving 110-foot aerial on Lavernock Point (seen in the distance in this postcard). The message sent in Morse code was 'ARE YOU READY'. A commemorative plaque was placed in the churchyard wall of Lavernock church by the Rotary Club in 1947. Flat Holm includes the most southerly point of Wales, as it is in the City and County of Cardiff, whereas Steep Holm is an English island, administered by North Somerset but owned by the Kenneth Allsop Memorial Trust. 'Holm' is derived from a Scandinavian word for an island in an estuary.

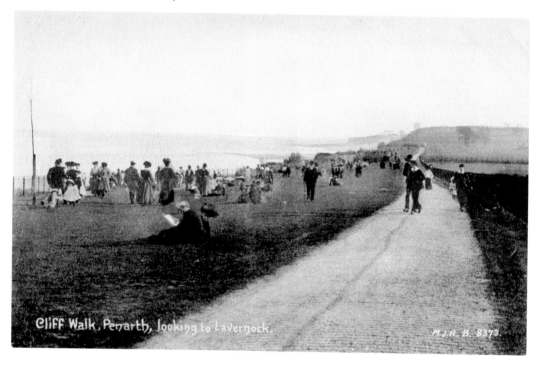

Cliff Walk, Penarth, looking to Lavernock.                    MJR B 8373.

## Station Hotel, Cogan

The extension of Penarth Dock westward led to the construction of the houses at Cogan to house dock workers and railwaymen. The first houses were Cogan Row, now part of Cawnpore Street and Hewell Street. The Taff Valley Railway houses of Pill Street were originally called Company Row. A brickworks was established near where the Cogan railway station is now (seen to the right in the background) to provide the bricks for the new houses and the Station Hotel, known locally as the 'Top House'. In 1910 the Earl of Plymouth gave the land for Cogan Recreation Ground to the town.

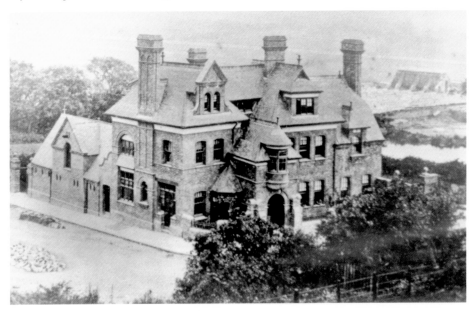

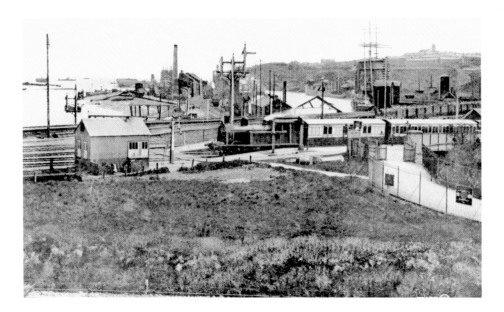

## The Dock and Harbour

Barry Dock and Railway built its line from Cogan via Dinas Powys to Cadoxton, whilst the Taff Vale Railway ran from Penarth to Lavernock, Sully, then Cadoxton. Penarth Dock and Harbour Station opened in 1878, renamed Penarth Dock Station in 1928. The two platforms at Penarth Dock Station were closed in 1962 when the line was reduced to a single track spur. Most of the station buildings still stand but have been used by several private businesses including a shooting range, a garden centre, a second-hand car lot and a marine chandlers. The area originally covered by the Cogan and Penarth Dock's railway sidings and engine maintenance sheds now contains a large supermarket.

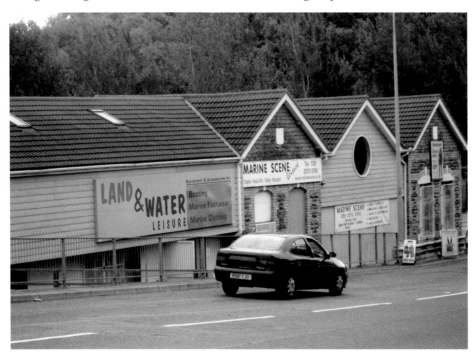

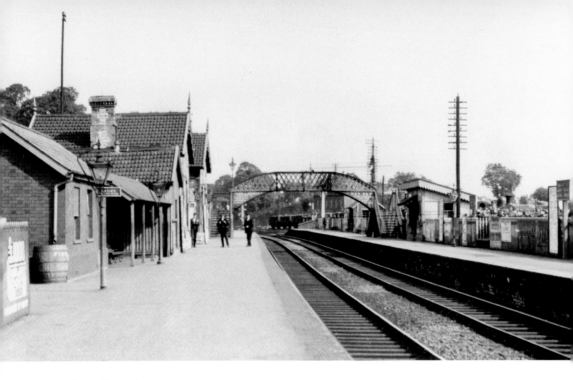

**Penarth Dock Station**

Here we see Penarth Dock Station viewed looking in a north-west direction. In the middle distance is Cogan Junction where the Barry Railway's lines joined those of the Taff Vale. The lines on the extreme right of the junction led down to Penarth Dock. The station was not open on Sundays and was mainly served by morning and evening rush-hour trains. The 2009 view shows the still functioning Cogan Station, which is only a very short distance away. This line, until June 2005, used to terminate at Barry, but now the passenger service carries on to Bridgend.

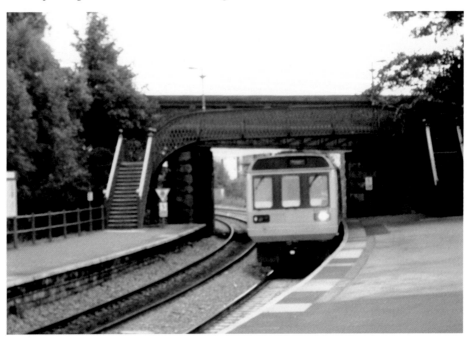

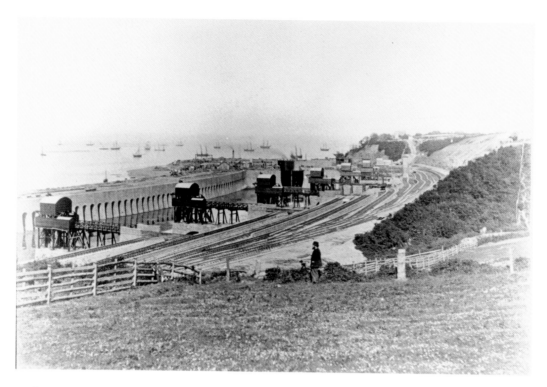

### Early Dock

The Penarth Harbour Dock and Railway Act, which was passed in Parliament in 1857, permitted the construction of a dock at the mouth of the Ely River at Penarth and a branch railway line to link the Harbour Dock with the Taff Vale Railway at Grangetown. The photograph shows how the dock was built under the north side of the headland, protected from the prevailing westerly winds, to fit into the natural curve of the land. The coal staithes and railway tracks are shown. These staithes were timber-framed structures where vessels could lie sitting on prepared mud berths at low water. (The 2009 satellite view is © 2009 Google – Imagery © 2009 Digital Globe, Infoterra Ltd & Bluesky, GeoEye, Getmapping plc, Infoterra Ltd & COWI A/S, The GeoInformation Group © 2009 Terrametrics, Map data © 2009 Tele Atlas.)

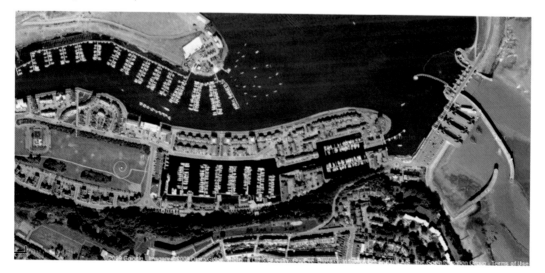

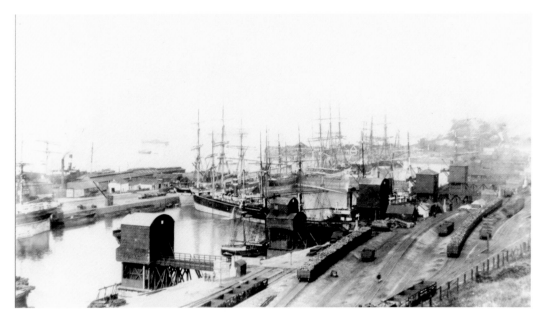

## Masts

The dock was opened on 10 June 1865. At 6 a.m. the ferryboat *Kate* left Cardiff Pier Head crowded with people who landed at the dock beach. At 7.30 a.m. the dock was declared open — Baroness Windsor had been due to perform the ceremony but she was late turning up! When she did turn up, she performed the renaming of the lifeboat from *George Gay* to *Harriet* (her first name).

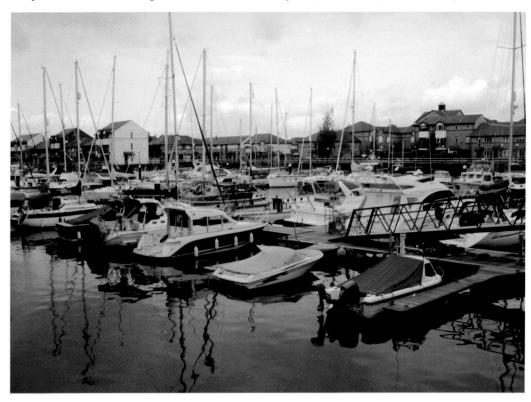

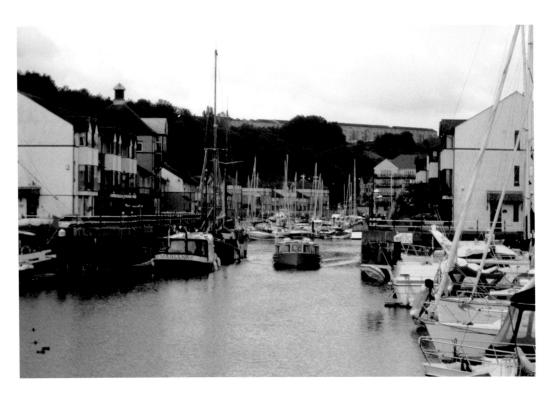

## The Staithes and Engine House

The large, square-rigged ships, which were unwieldy in close waters, provided almost all the casualties for the Penarth lifeboats. Railway trucks bearing the name LEWIS are in the foreground of this postcard. Two of the coal staithes are also shown, each capable of shipping 150 tons of coal an hour. These staithes were timber-framed structures where vessels could lie sitting on prepared mud berths at low water. The structures were equipped with cradles by means of which the coal wagons were gravitated to and from the tips. The Engine House for the docks, with its distinctive chimney, is in the centre.

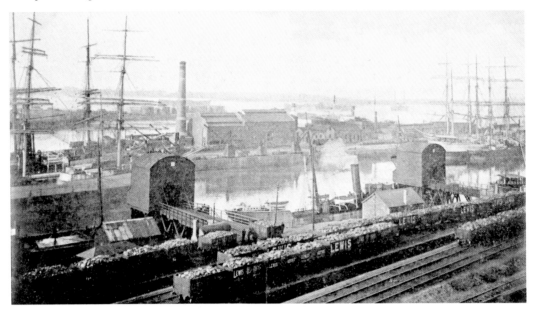

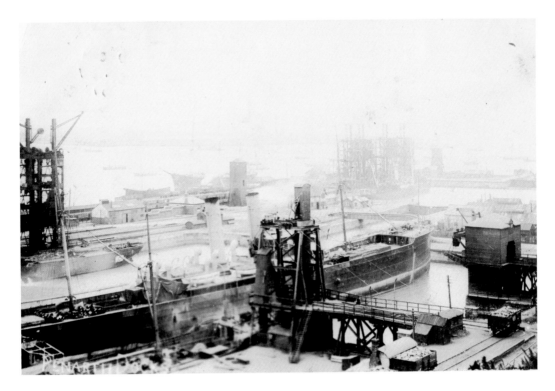

## Subway

The subway connected Penarth to Grangetown under the River Ely. This replaced the ferry, a large raft with a canopy which two men worked a windlass to propel across the river. The subway was used by commuting pedestrians and cyclists as a short cut to work in Cardiff. The toll was 1*d* for pedestrians, 2*d* for bicycles and 4*d* for prams. Policemen and postmen were exempted from the tolls. Tolls were collected up to 1937. During the Second World War the subway was used as an air raid shelter. This historic short cut route was 'almost' replicated and replaced in June 2008 with the opening of a pedestrian and cycle route across the new Cardiff Bay Barrage. The modern aerial view by Vilis Kuksa shows the Bay and the Barrage.

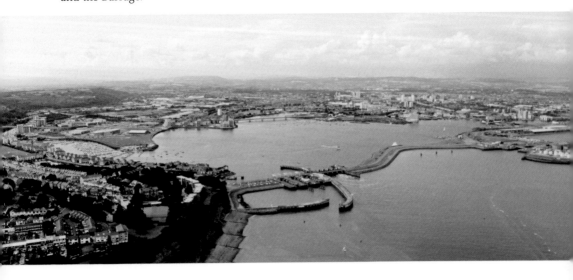

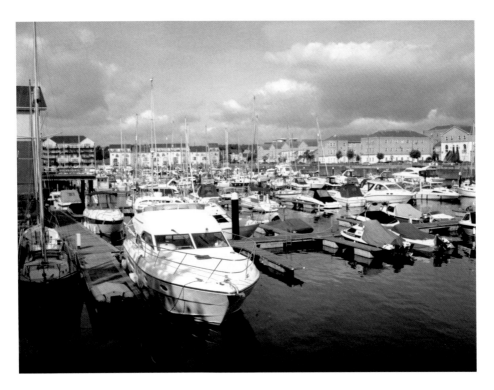

## Subway (continued)

The subway was nearly fifty feet below the high-water mark and its length was 1,250 feet. The subway was actually a large pipe with an external diameter of ten feet and an interior diameter of eight feet, ten inches. Lined with cream and green coloured ceramic tiles, the route was lit originally by gaslight and later by electricity. Opened in 1900 the tunnel remained in use until 1965 when it was closed and the ends were bricked up. The author remembers many journeys though the subway.

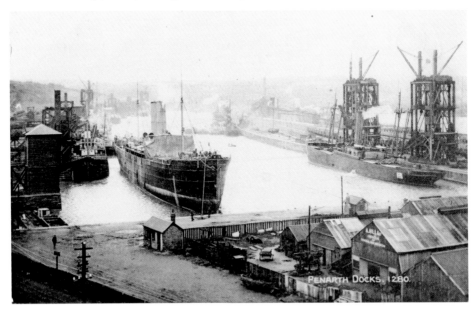

PENARTH DOCKS, 1280.

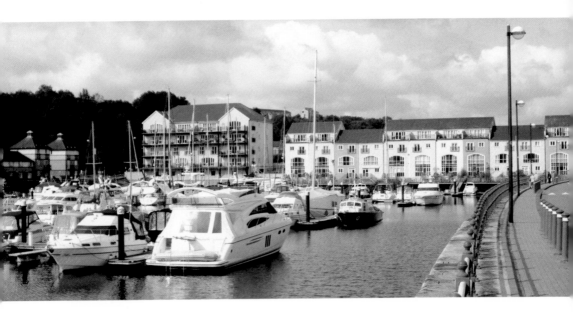

## Sail and Steam

A mixture of square-rigged sailing ships and steam ships. The wooden jetties of the Ely River Tidal Harbour are on the right across the river. The *Cutty Sark* visited Penarth in 1880. In 1886 the SS *Great Britain*, built by Isambard Kingdom Brunel, left Penarth Dock bound for Panama via Cape Horn. An unsuccessful attempt to 'round the Horn', in which extensive damage occurred, resulted in her being abandoned in the Falkland Islands. In 1970 an ambitious salvage effort brought her home to Bristol, where today she is conserved in the dry dock where she was originally built.

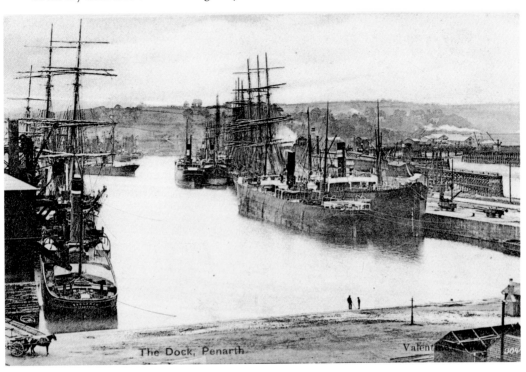

The Dock, Penarth

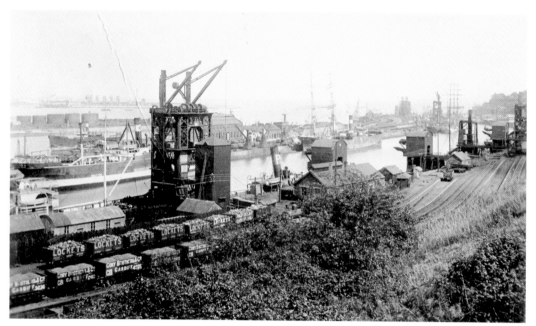

### The Pontoon

The pontoon, a floating dock, was towed to Penarth in October 1909, in two parts that were joined up when they reached Penarth. When the pontoon's tanks were filled with water it sank. The ship was then manouvered into position and the water pumped out of the tanks lifting the pontoon and the ship out of the water. The pontoon was capable of lifting 1,000 tons dead weight in 45 minutes, and taking ships up to 4,500 tons. The modern aerial view is © Quay Marinas PLC.

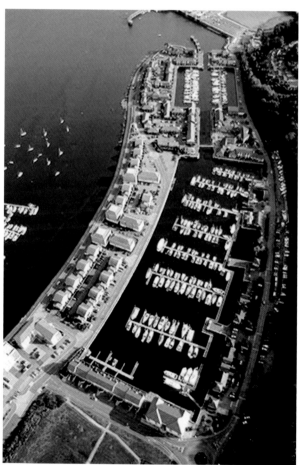

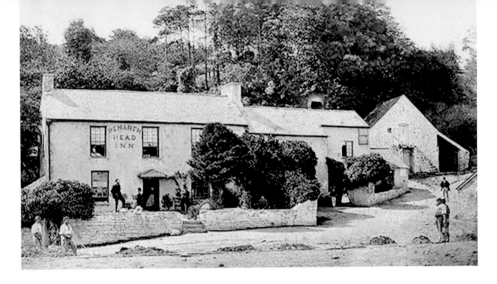

### The Penarth Head Inn and Customs House

The Penarth Head Inn, situated at the base of Penarth Cliff, is pictured just before its demolition in 1864. It was the home of Edwards the Smuggler in the eighteenth century. In 1865 it was replaced by Customs House and the Marine Buildings, with shops on the ground floor — a post and telegraph office, a chemist, an optician, a grocer, a ship's butcher and a ship's chandler, and accommodation for the better-off captains and business men on the upper two floors. The Marine Hotel, which was at the seaward end of the Marine Buildings, closed in the 1930s through lack of custom. Now Customs House is the site of two restaurants, El Puerto, a renowned brassiere and La Marina, one of the top fish restaurants. Both offer a collection of fresh fish, like sole, sea bass, king scallops and oysters or succulent meats and game all of which are displayed in an open counter for you to choose from.

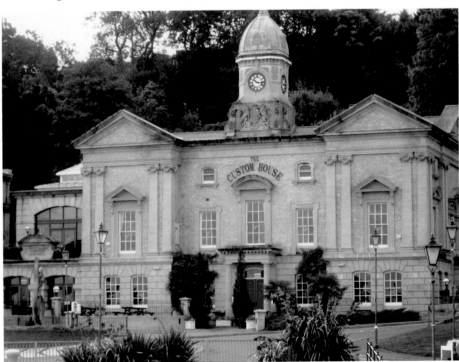

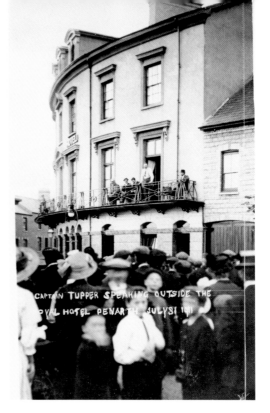

## The Royal Hotel

This postcard shows 'Captain' Tupper the seamen's leader addressing longshore men on 31 July 1911 from the balcony of the Royal Hotel, on the corner of Queens Road and Arcot Street. Strikes were resulting from unorganised casual cheap labour and low wages. This meeting affirmed action against blackleg workers operating from a moored boat off Penarth Head. The 2009 view shows how the hotel has been converted into apartments.

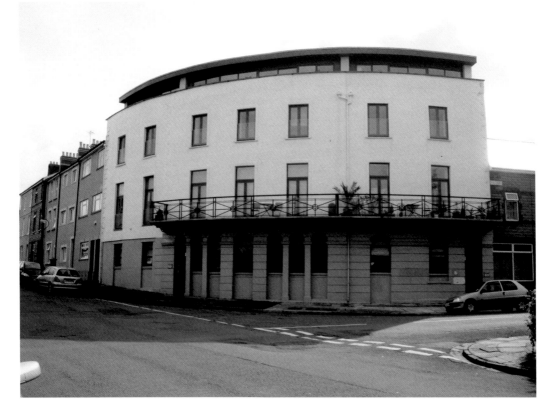

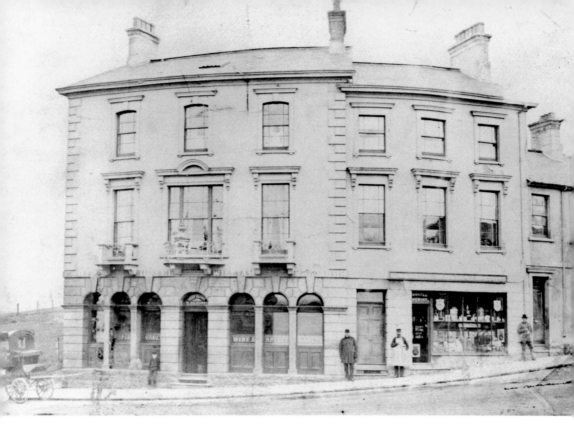

### The Ship Hotel

The Ship Hotel and Proctor's chemist shop, on the corner of Glebe Street and Maughan Street (which became Queens Road in honour of the Queen's Coronation in 1953). Maughan was the agent to the Windsor/Clive family. There was an hourly horse-drawn bus service from the Ship Hotel to St Mary Street in Cardiff. The Ship Hotel closed just before the Second World War through lack of custom and was demolished soon after. The Catherine Meazey flats were built on the site. The 2009 view shows the nearby view out over Cardiff Bay.

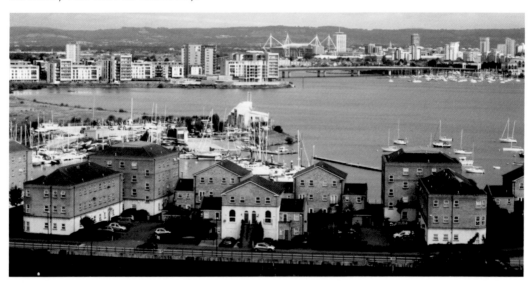

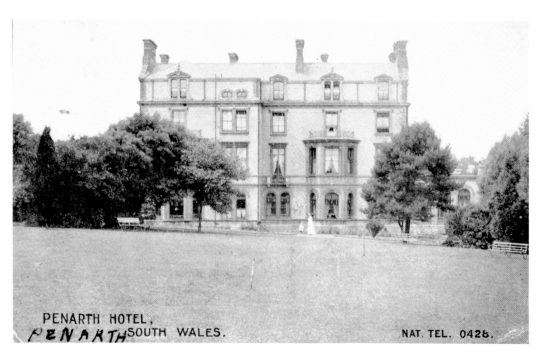

PENARTH HOTEL,
PENARTHSOUTH WALES.                    NAT. TEL. 0428.

## Penarth Hotel

Penarth Hotel was built by the Taff Vale Railway in 1868. The hotel had a large coffee room, with 'kettledrum parties' — informal social parties held in the afternoon or early evening — and dancing on offer. Lawn tennis and archery was also available. Being far away from the town centre and the beach, and with new hotels being built nearer the railway station, especially the Lansdowne Hotel and Esplanade Hotel, the Penarth Hotel became uneconomical to run.

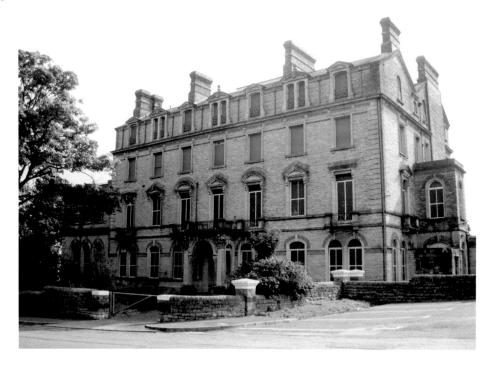

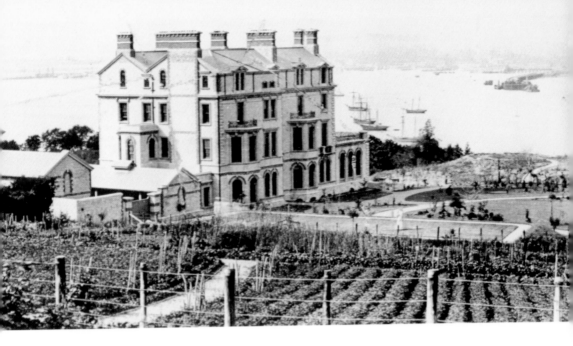

## A Rear View of Penarth Hotel

Mrs Gladys Gibbs (nee Morel) bought the hotel as a memorial to her husband who was killed in action in 1917 and opened it as a branch of the National Children's Home, as a nautical training school. In the mid-1920s Stanley Unwin attended and learnt about wireless telegraphy and obtained a first-class Postmaster General's Certificate. The epitaph on his and his wife's gravestone reads 'Reunitey in the heavenly-bode — Deep Joy'. In 1936 it became a school for delinquent boys and after the Second World War it became the Headlands School, a school offering care and education for emotionally damaged young people.

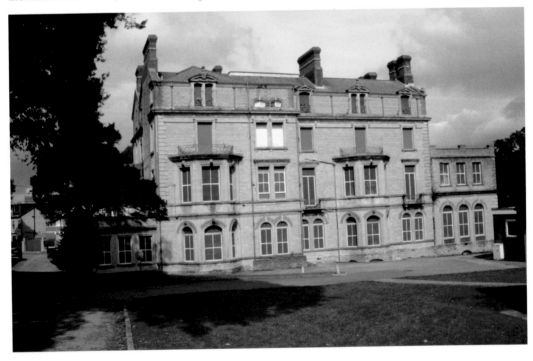

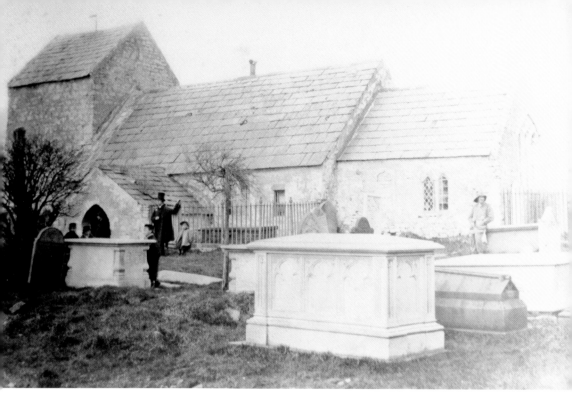

### Old St Augustine's Church

The highest point in Penarth, about 220 feet above sea level, was for centuries the site of a religious settlement. The photograph, *c.* 1864, shows the Revd Charles Parsons and Teddy the Rocking-Boat, the sexton with a limp and a notorious temper, outside the original St Augustine's church just before it was demolished.

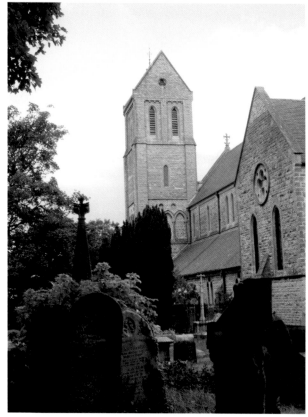

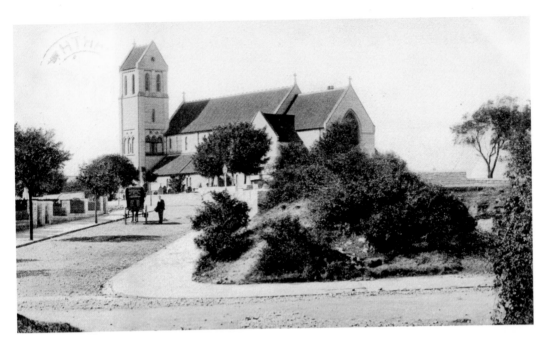

**St Augustine's Church**

The new church, built in 1866, was designed by the famous Victorian architect William Butterfield, who also designed Keble College, Oxford. The ninety-foot saddle-backed church tower is a prominent landmark. A pillar surmounted by a harp marks the grave of the composer Dr Joseph Parry.

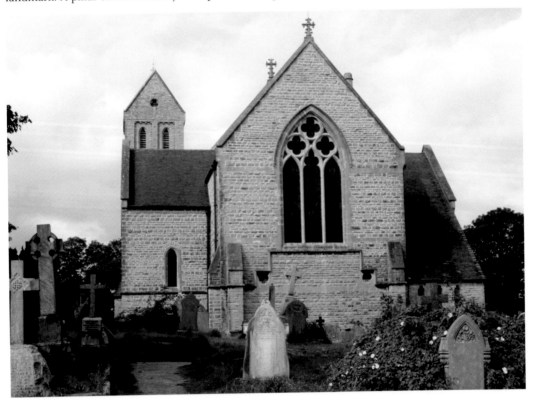

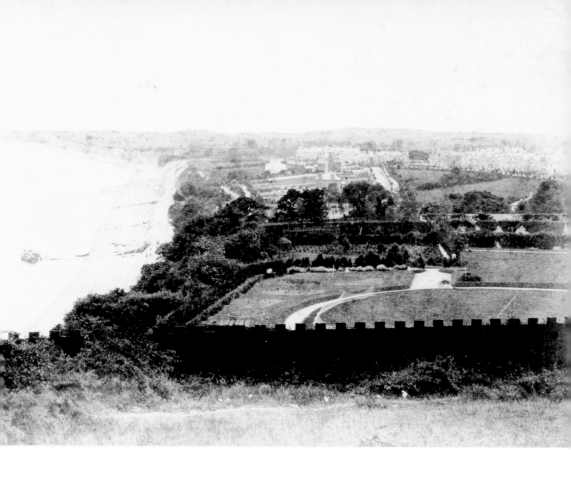

**An Early View from Penarth Head**
This photograph was taken from Penarth Head, prior to the building of the pier in 1894. The Cardiff-Penarth ferry can be seen at the landing stage on the beach. The modern aerial view is by Vilis Kuksa.

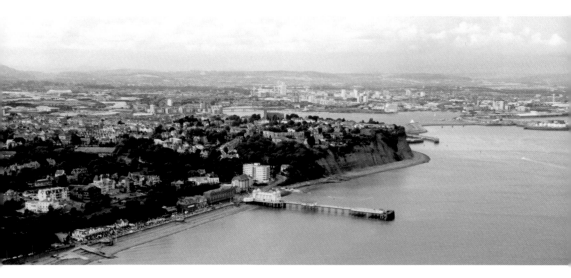

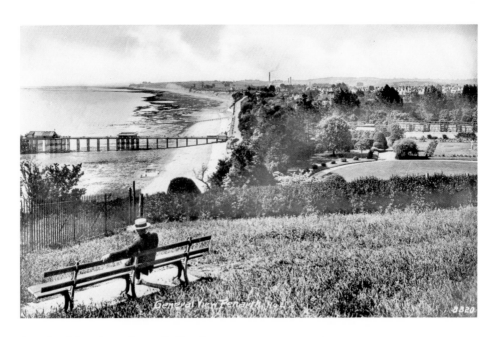

### Another View from Penarth Head

This is a later view, again taken from Penarth Head but this time showing the pier and also the paddling pool on the beach. The smoking stacks of Penarth Cement Works can be seen in the far distance. When the cement works closed, it was the last large industrial site in the area to employ local labour. The Schooner Inn Harvester is on the site of the offices, Cosmeston Park and Lakes replaced Downwood Quarries which opened in 1890. Cosmeston Medieval Village is a 'living history' village, a re-creation of fourteenth-century peasant life. The village regularly plays host to groups of re-enactors, who camp in authentic tents around the outskirts of the village and do displays of combat for the public. The Cosmeston photo is by Jennie Powell.

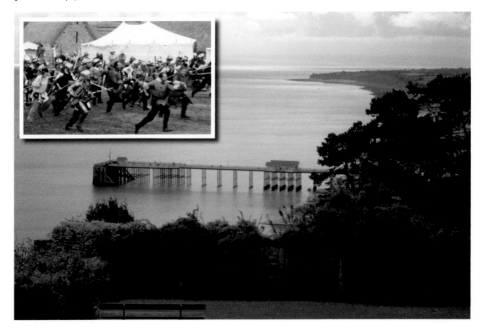

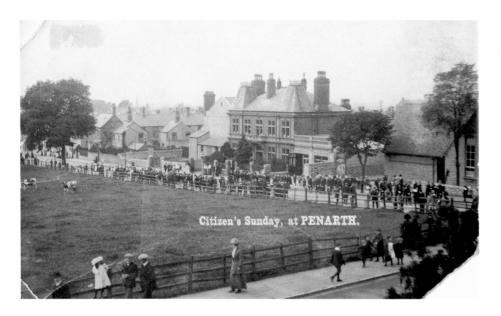

Citizen's Sunday, at PENARTH.

## Citizen's Sunday and Albert Road

Citizen's Sunday was held to commemorate a new council chairman (later mayor) taking office. Albert County Primary School was the first board school in the town when it opened in 1876. The school was designed by Henry C. Harris, who also co-designed Penarth Public Swimming Baths, but John Coates Carter designed the extensions with Art Nouveau decorated panels on the gable ends. Its unique murals of schoolchildren were painted ten years later. Belle Vue Court is now in residential use, but was the town's first fire station and the offices of the Urban District Council.

**From Belle Vue Bowling Green Towards St Augustine's**

Belle Vue Park opened in 1914. The bowling-green area of the park was once a quarry so deep that after heavy rain in 1877 two brothers were drowned in it. This postcard shows the bowling green and Albert Crescent winding its way up to St Augustine's church.

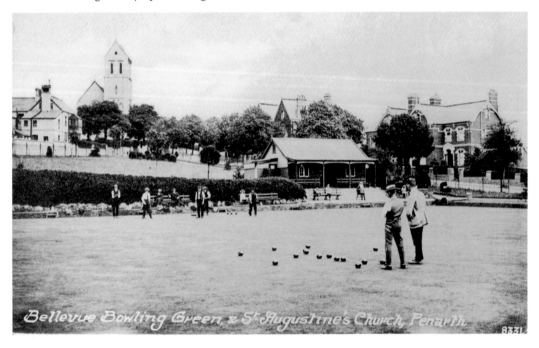

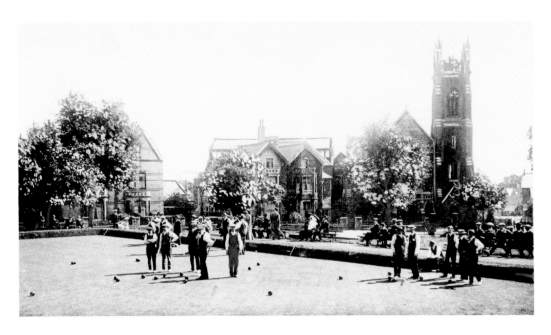

### The Bowling Green & Wesleyan Church

This postcard shows a view of the other end of the bowling green, with the Wesleyan church in the background. The church was built to replace the Wesleyan church in Arcot Street that was burned to a shell in 1905. The shell was bought by the Anglican Church who re-built it as St Paul's.

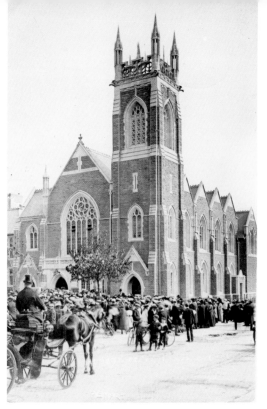

### Albert Road Wesleyan Church

Albert Road Wesleyan church during its opening ceremony on 29 May 1907. The postcard shows a large crowd gathered outside the church, on the junction of Albert Crescent and Albert Road. In 1973 it was decided to convert the church and schoolroom into a multi-purpose building offering a wide variety of community service while remaining a place of worship.

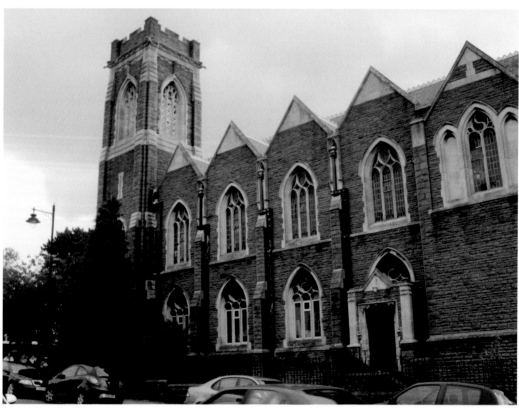

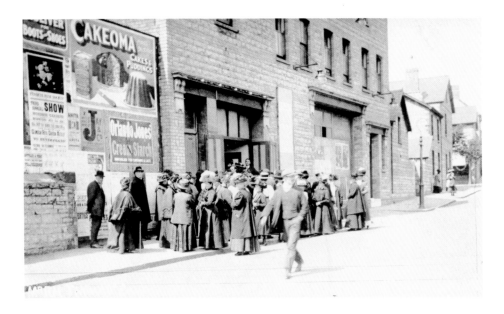

## Lower Albert Road

Solomon Andrews' Large Hall was built in Albert Road in 1892. In 1911 it became the Picturedome cinema. In 1924 it became the Albert Hall Cinema run by the Willmore Brothers, who leased the hall from the Andrews family. During the 1920s it was also known as the Hippodrome. From 1887 until 1929, when it was destroyed by fire, it was used for meetings, films, variety shows and productions by the Penarth Operatic Society. One of the posters in the photograph advertises Penarth Rose Society Third Annual Show, Windsor Gardens. The 2009 view shows the Royal Mail sorting office.

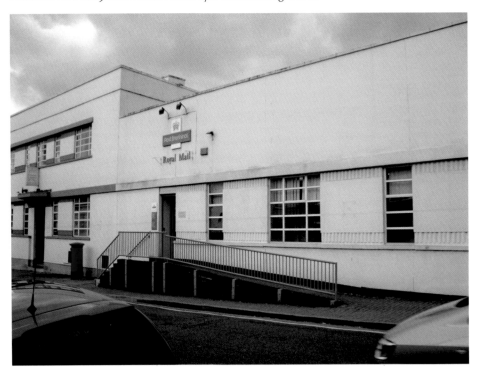

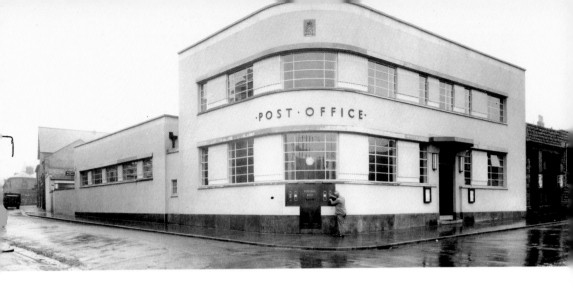

### The Old Post Office

On the corner of Ludlow Lane and Albert Road, stands the former general post office, designed by A. R. Myers in Art Deco style and built in 1936. Closed in the 1980s, the building is Grade II listed and now converted as a restaurant offering Bangladeshi cuisine. The rear yard, once used to stable horses for the horse-drawn Penarth to Cardiff bus service, is still used by the post office for mail and parcel sorting, although the post office's counters service has transferred to Glebe Street.

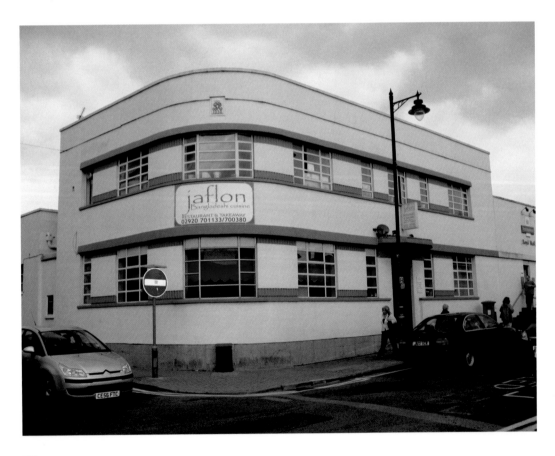

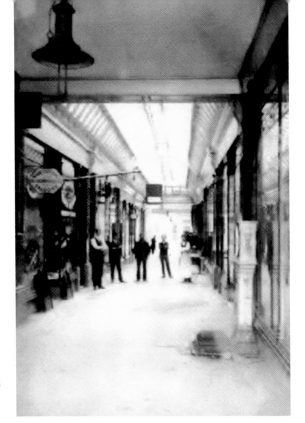

## Windsor Arcade

Windsor Arcade was designed by the architect E. Webb and built in 1898 for Solomon Andrews. Today the shops include Windsor Fruit Stores, North Meets South café, Windsor Restaurant & Tea Room, Barnums Toy Shop, Hair Work hairdressers, and Dancewear Unlimited. The 2009 view is from the Ludlow Lane end looking down to the Windsor Road end.

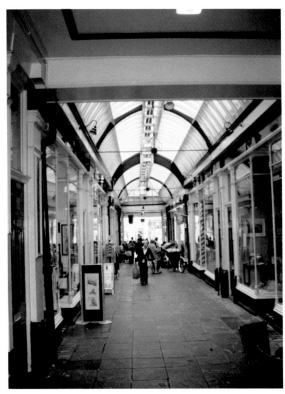

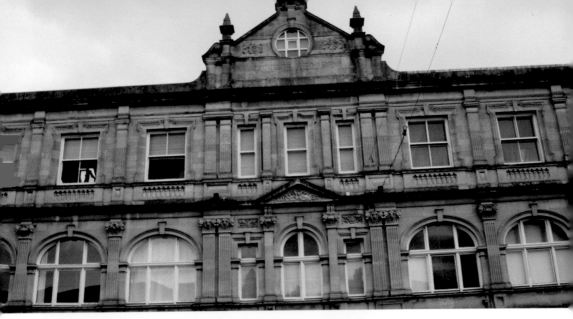

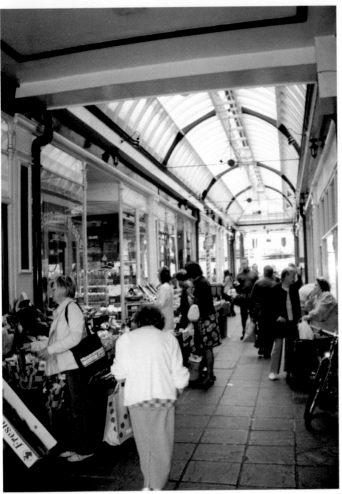

## Windsor Lofts

The Windsor Lofts apartments, above Windsor Arcade, retain the original beams and roofing from the nineteenth century, utilizing the large attic space by creating mezzanine areas for use as a sleeping area, gym or work area. Here we have the 2009 views of Windsor Lofts from Windsor Road and Windsor Arcade looking from Windsor Road end up to Ludlow Lane.

**Maps of Penarth, 1885 and 2009**
In an 1876 letter, Earl Plymouth's land agent for Penarth, Robert Forrest, sought to actively discourage the 'rabble from the hills' who came by train, and 'those persons who swim in the sea either without a bathing costume, or without sufficient modesty to change into one hidden from public view. We cannot stop the rabble coming to Penarth but we can throw obstacles in their way of their getting accommodation and that may have the desired effect in the end. My aim is to increase the comforts of the residents and legitimate visitors and entice respectable people to come here to reside.' (The 2009 view is © 2009 Google – Imagery © 2009 Digital Globe, Infoterra Ltd & Bluesky, GeoEye, Getmapping plc, Infoterra Ltd & COWI A/S, The GeoInformation Group © 2009 Terrametrics, Map data © 2009 Tele Atlas.)

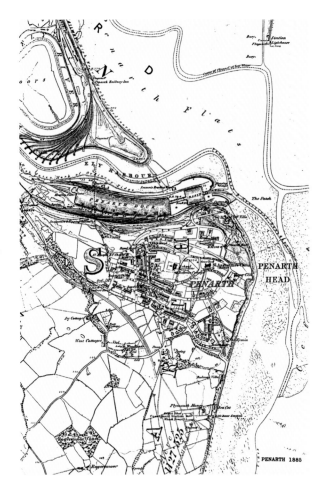

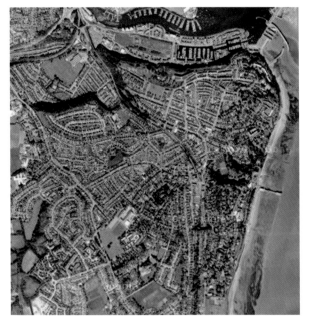

# Acknowledgements

In writing the paragraphs to accompany the photographs in this book I have drawn upon the works of fellow authors on Penarth: Roy Thorne, Alan Thorne, Barry Thomas, Phil Carradice, Geoffrey North, and Chrystal Tilney.

My thanks go to the following: Paul Dyer for use of his *Dr Who* photograph; The BBC for the *Merlin* photographs; Quay Marinas for the aerial views of Penarth Marina; Vilis Kuksa of Penarth Framing Services, Victoria Bridge, www.penarthframing.com; Jennie Powell for the Cosmeston 'charge' photograph; The British Postal Museum and Archive for the post office photograph.

© 2009 Google-Imagery; © 2009 Digital Globe; Infoterra Ltd & Bluesky; GeoEye; Getmapping plc; Infoterra Ltd & COWI A/S; The GeoInformation Group © 2009 Terrametrics; Map data © 2009 Tele Atlas for the 2009 satellite views of Penarth.

The present day photographs were taken in August and September 2009.

© Cardiff Harbour Authority

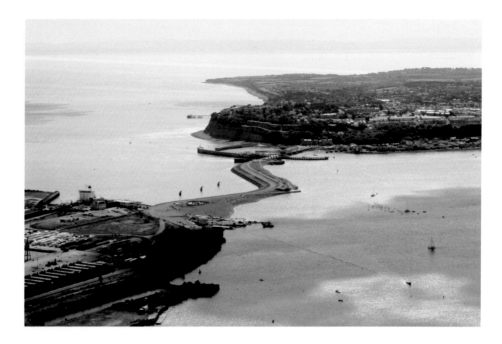